CHURCHES OF MINNESOTA

CHURCHES OF

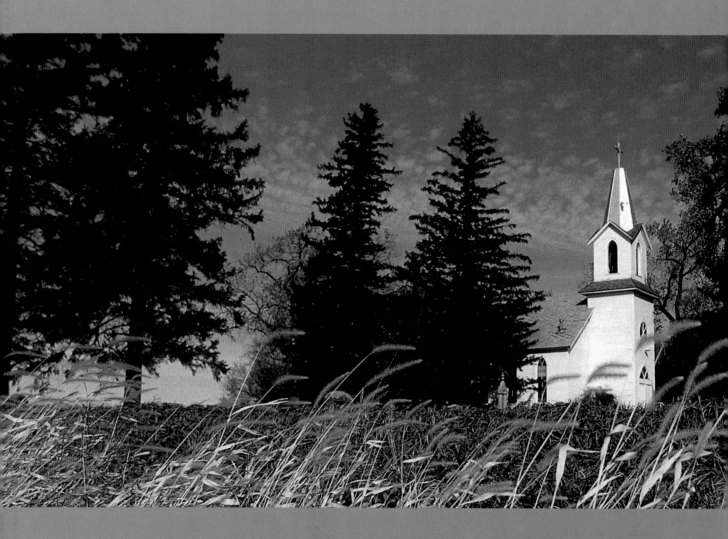

minnesota byways

MINNESOTA

Enjoy!

Doug S. O...

2014

Photography and captions
by Doug Ohman

Text by Jon Hassler

MINNESOTA HISTORICAL SOCIETY PRESS

minnesota byways

Barns of Minnesota
Churches of Minnesota

© 2006 by Minnesota Historical Society Press.
Text © 2006 by Jon Hassler. Photographs © by Doug
Ohman. All rights reserved. No part of this book may
be used or reproduced in any manner whatsoever
without written permission except in the case of brief
quotations embodied in critical articles and reviews.
For information, write to the Minnesota Historical
Society Press, 345 Kellogg Blvd. W., St. Paul, MN
55102-1906.

www.mnhs.org/mhspress

The Minnesota Historical Society Press is a member
of the Association of American University Presses.

Manufactured in China by Pettit Network, Inc.,
Afton, Minnesota

Book and jacket design by Cathy Spengler Design

10 9 8 7 6 5 4 3 2 1

♾ This book is printed on a coated paper
manufactured on an acid-free base to ensure
a long life.

Portions of this text have been published,
in slightly different form, in an essay titled
"Remembering Churches" in *Why I am Still
a Catholic*, edited by Kevin and Marilyn Ryan
(New York: Riverhead Books, 1998).

Photograph, pp. i–ii: Clear Lake Evangelical
Lutheran Church, Gibbon (Sibley County),
1872/1880, Carpenter Gothic

International Standard Book Number
ISBN-10: 0-87351-547-1 (cloth)
ISBN-13: 978-0-87351-547-4 (cloth)

Library of Congress Cataloging-in-Publication Data

Ohman, Doug.
Churches of Minnesota / photography and captions
by Doug Ohman ; text by Jon Hassler.
 p. cm. — (Minnesota byways)
ISBN 0-87351-547-1 (cloth : alk. paper)
 1. Church architecture—Minnesota—Pictorial works.
 2. Church buildings—Minnesota—Pictorial works.
 I. Hassler, Jon.
 II. Title.
 III. Series.

NA5230.M5O37 2006
726.5′09776—dc22
 2005010432

CHURCHES OF MINNESOTA

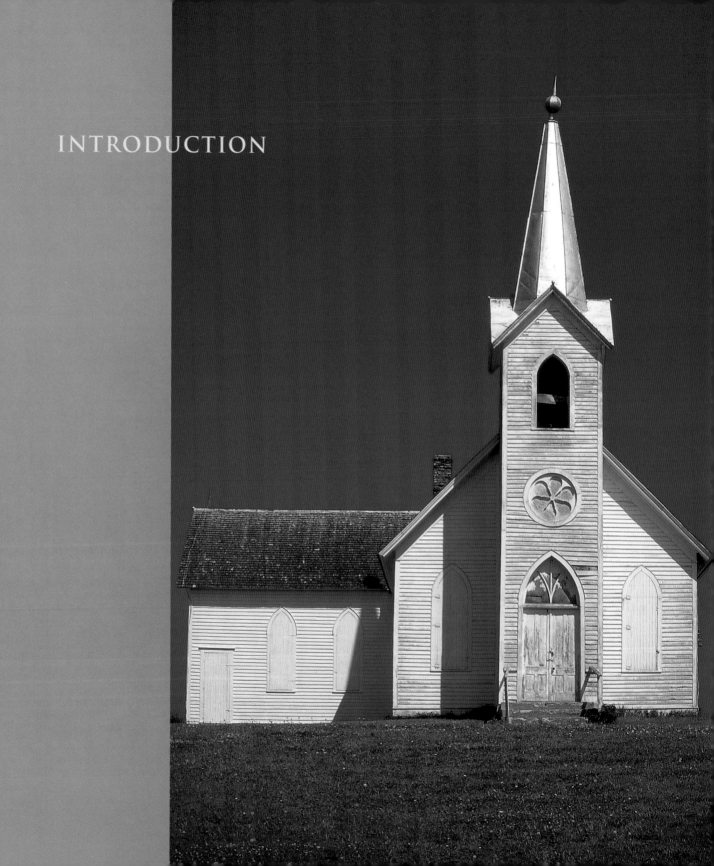

INTRODUCTION

I am fascinated by churches. They are spaces set aside to satisfy humankind's spiritual longing. Whether a basilica on a busy city street or a small country church standing among cornfields, I never see one that I don't want to go inside to look around, to soak up the holiness. I can easily imagine the excitement and pride of the founding congregation on the day a pastor or bishop showed up to dedicate the place. But of course it was the parishioners themselves who truly consecrated the church by holding their life-changing ceremonies at the altar. Generations of baptisms, weddings, and funerals account for the holiness we feel.

Church served as a social venue as well. Immigrants came seeking likeminded compatriots to talk to, away from the strangers they lived among. Even now they still provide comfort to those who like being among their own kind. We are told that America is increasingly a nation of churchgoers, which means that, although here and there a church is closed for lack of attendance, many that catch our eye today are still functioning as they have for the past hundred or two hundred years.

Church architecture hasn't changed much over the years. Look at the photographs in this book and you will see that no matter how designs change, a steeple or bell tower is always essential, or at least a cross prominently displayed. I have been in modern churches that resemble nightclubs or basketball arenas, yet outside, because of their towers or crosses, it is difficult to mistake them for anything but a church.

In this book I take you inside a number of churches that have been important to me, a lifelong Minnesotan, and Doug Ohman presents exquisite photographs of many places of worship that dot our Minnesota landscape.

JON HASSLER
Minneapolis, Minnesota

PREVIOUS PAGE Bethany Lutheran Church, Spicer (Kandiyohi County), 1879, Gothic Revival

BELOW Lac qui Parle Mission Chapel, rural Chippewa County, 1940, sits on the site of the original adobe structure from 1835.

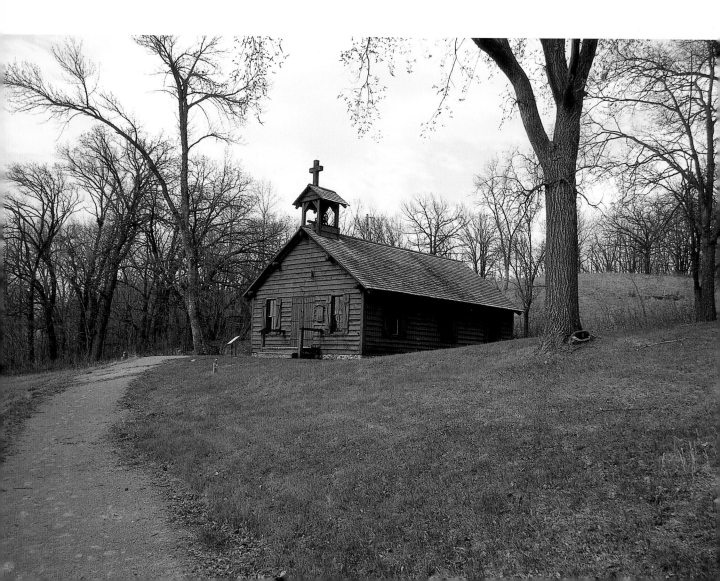

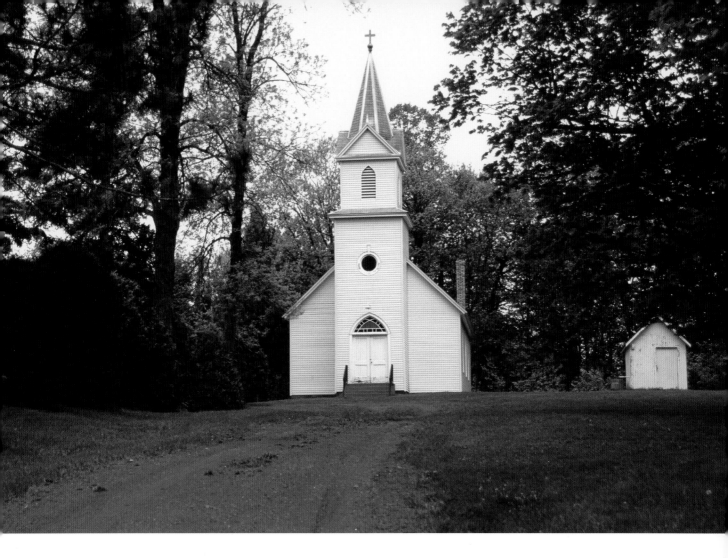

ABOVE Maria Chapel, Aitkin (Aitkin County), 1888–89, Gothic Revival

In the late 1880s, eight newly arrived Swedish families began talking about building a church so their children could have religious instruction. Under the leadership of Pastor Sjoblom, the Swedish Evangelical Maria Church was organized on March 14, 1888. The next year the congregation began to build a 40-by-26-foot church near their settlement southeast of Aitkin. To pay for the project, annual dues were set at two dollars per man and one dollar per woman. Dues were increased in 1895 to help pay for a minister that came from Brainerd once a month. Regular services continued until 1930, when members voted to merge with the Lutheran church in Aitkin.

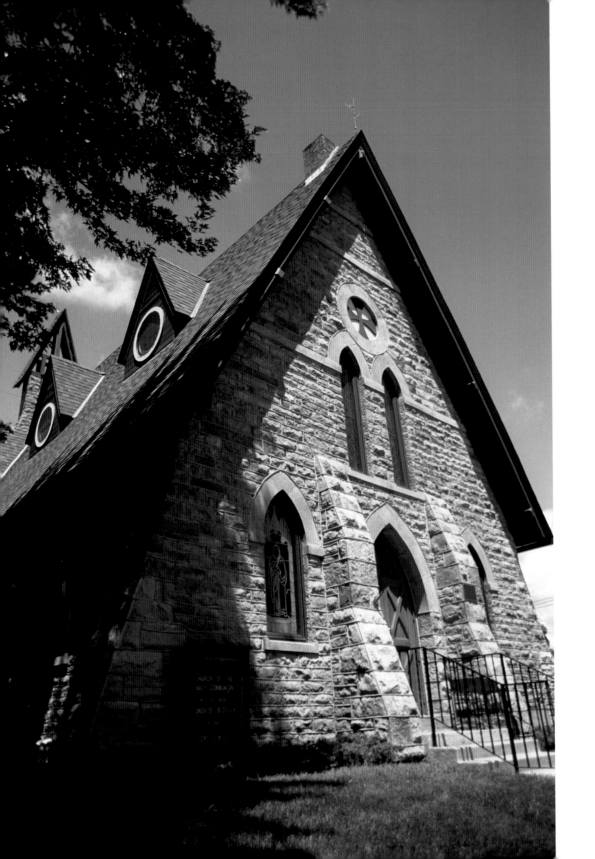

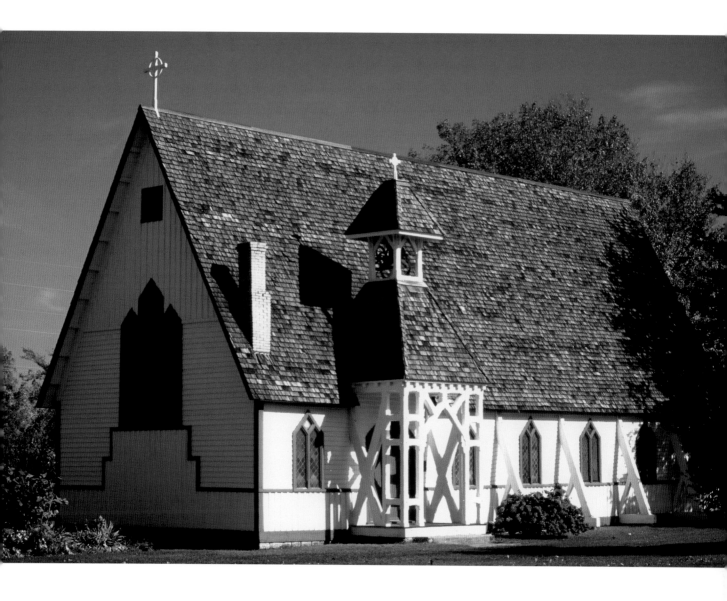

LEFT Church of the Holy Communion, St. Peter (Nicollet County), 1869, English Gothic Revival, National Register (1983)

ABOVE Episcopal Church of the Transfiguration, Belle Plaine (Scott County), 1869, Eastlake, National Register (1980)

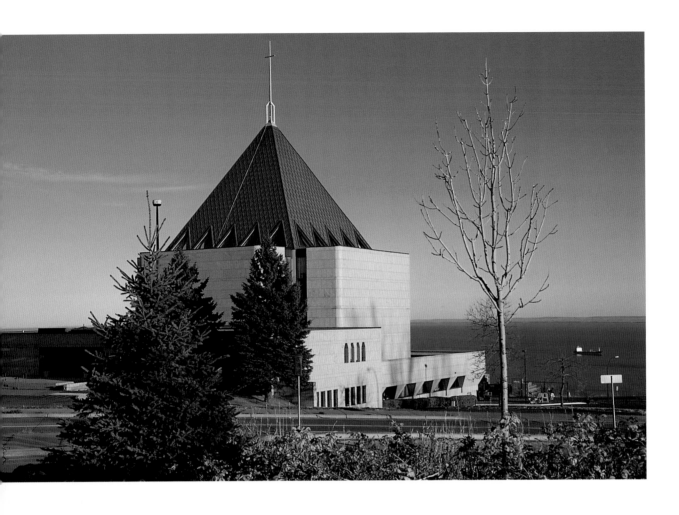

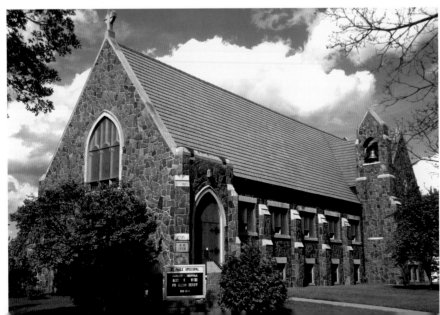

During his brief administration at Immaculate Conception Church, Father Snyers was looking for a sponsor for the church basketball team. Having some difficulty finding one in the village of Rice, he decided to write to the executive board of Kellogg's Cereal in Battle Creek, Michigan. A few weeks later he received a positive reply, and the team was often called the "Rice Krispies."

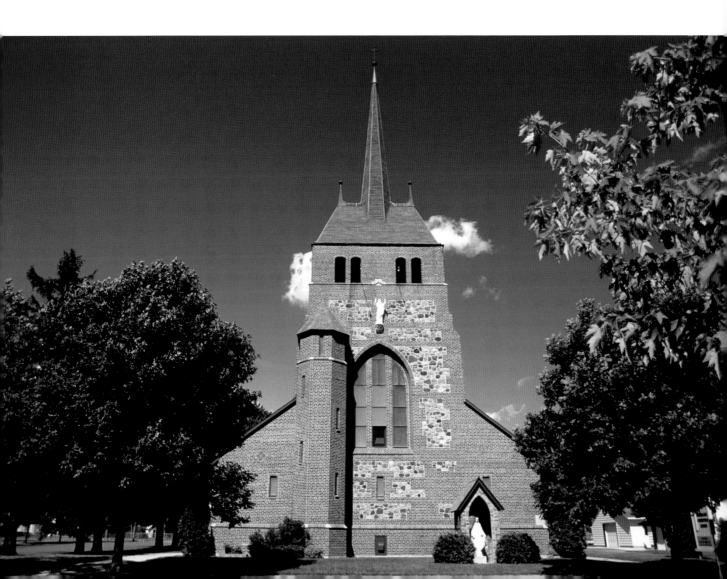

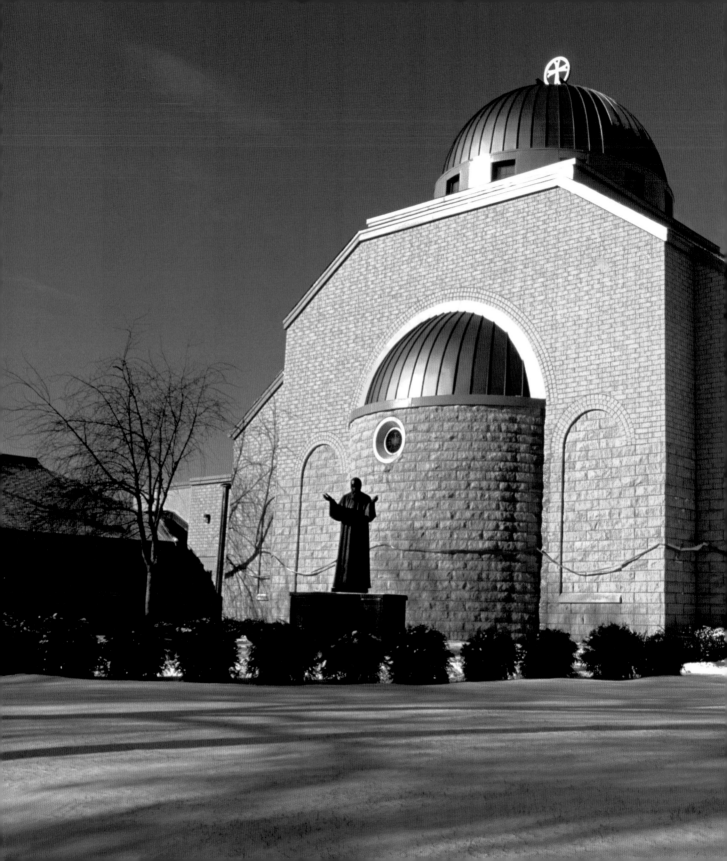

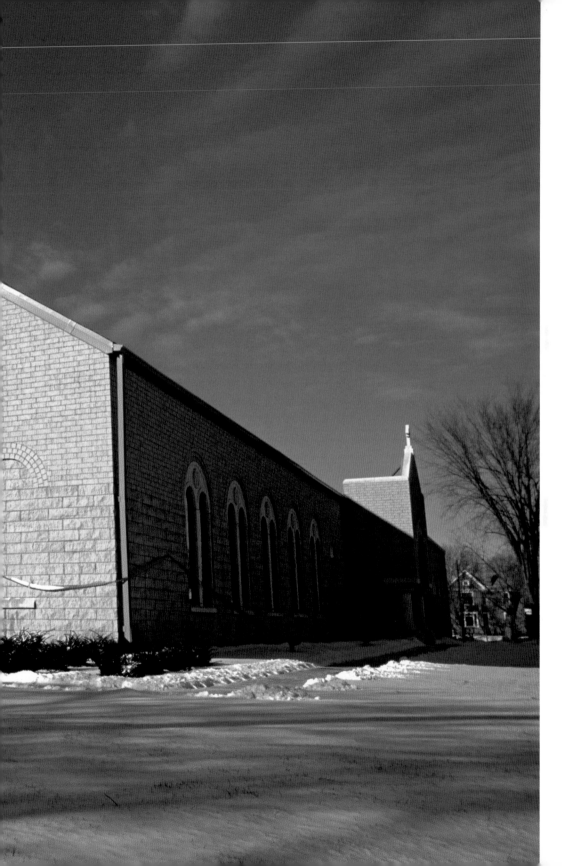

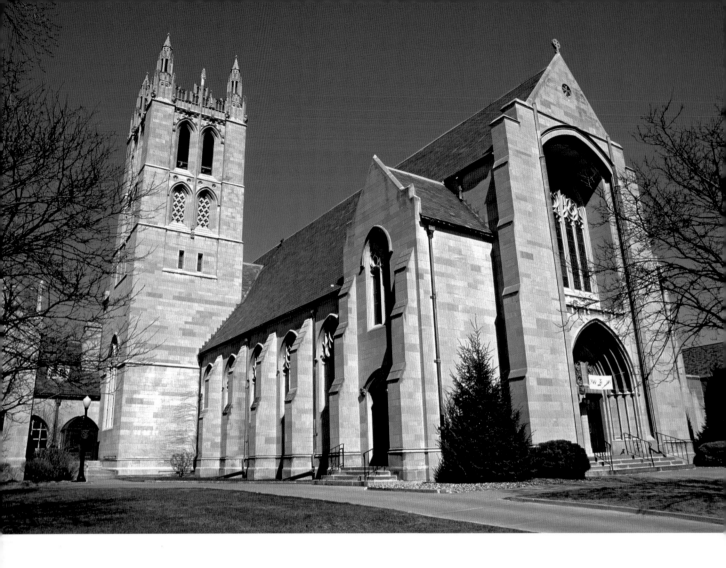

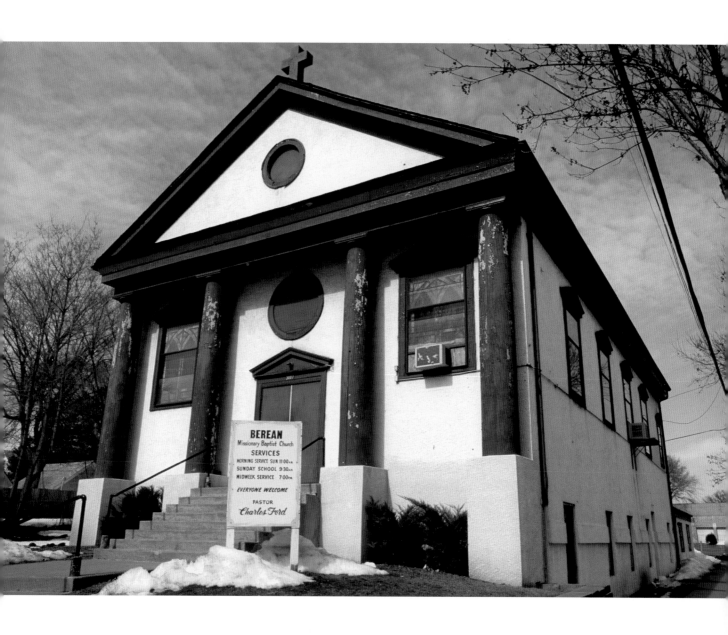

ABOVE Little White Church in the Valley (Golden Valley Historical Society), Golden Valley (Hennepin County), 1882

BELOW St. Alphonsus Catholic Church, Brooklyn Center (Hennepin County), 1959/1969

ABOVE **Fish Lake Lutheran Church, Harris (Chisago County), 1867/1886, Gothic Revival**

Fish Lake Lutheran Church was organized on February 19, 1867. In 1870 the Lake Superior & Mississippi Railway Company gave the congregation forty acres of land on which to build a church. The first church building was completed in 1875, only to be struck by lightning and burned to the ground eleven years later. Shortly after the tragic fire, the current church was built. In 1880, the Augustana Synod of the Minnesota Conference held its annual meeting at Fish Lake Lutheran Church, at which the first steps were taken to establish Bethesda Hospital in St. Paul.

ABOVE Seven Dolors Catholic Church, Albany (Stearns County), 1868/1900, Gothic Revival

The parish of Seven Dolors received its name and patron due to a remarkable incident. Simon Groetsch, a member of the congregation, was digging deep in a new well on his farm when, as a family member drew up a bucket of earth, the pulley slipped, sending the bucket plummeting toward Simon. Seeing instant death, Simon called out to the Sorrowful Mother. That instant, the rope became tangled and the bucket stopped inches above his head. In thanksgiving, the Groetsch family donated a statue of the Seven Dolors (Sorrows) to the parish. The statue, brought from Bavaria by immigrant friends, was carried from the Groetsch farm to the church on July 17, 1870. Soon after, the parish, originally called Two River Mission, adopted its new name in honor of the event.

BELOW Round Prairie Lutheran Church, Glenville (Freeborn County), 1865/1923, Gothic Revival

NEXT PAGES Cathedral of Saint Paul, St. Paul (Ramsey County), 1841/1906–14, Baroque, National Register (1974)

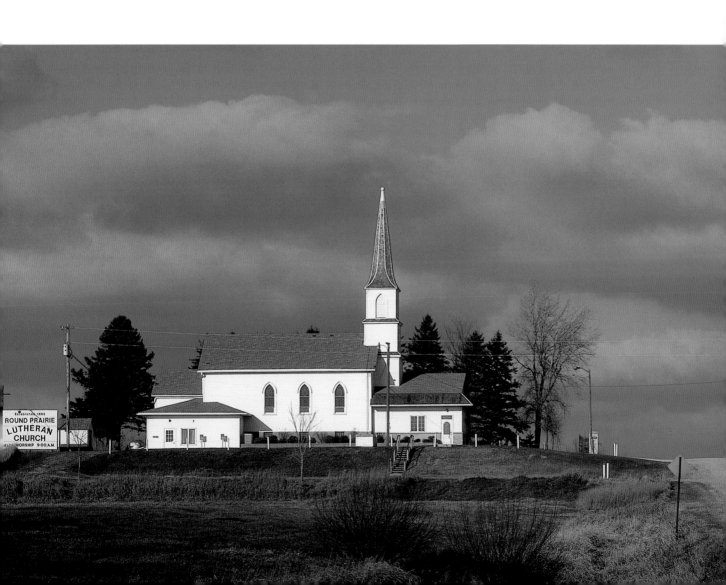

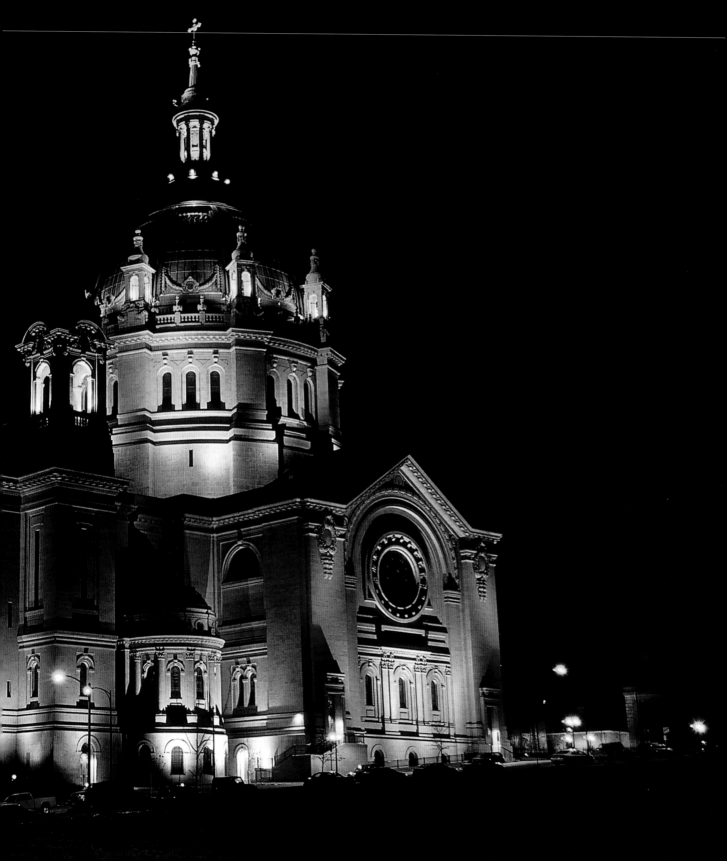

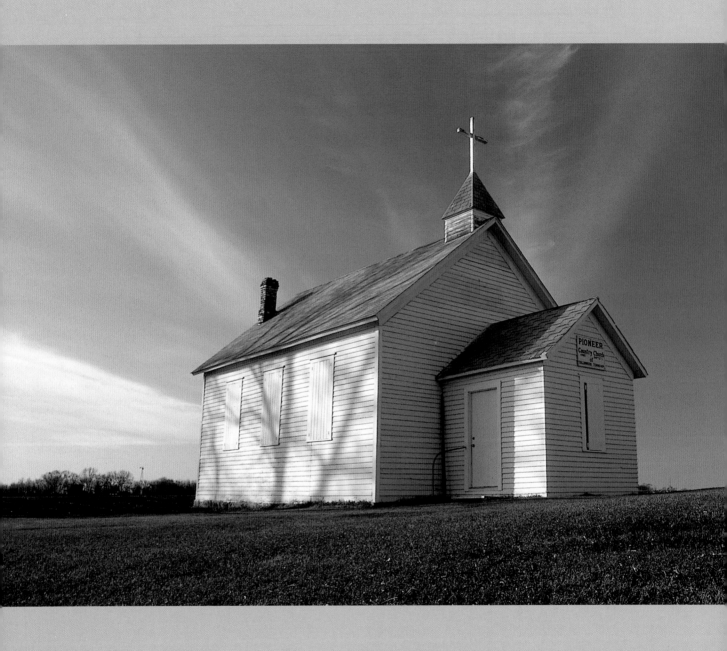

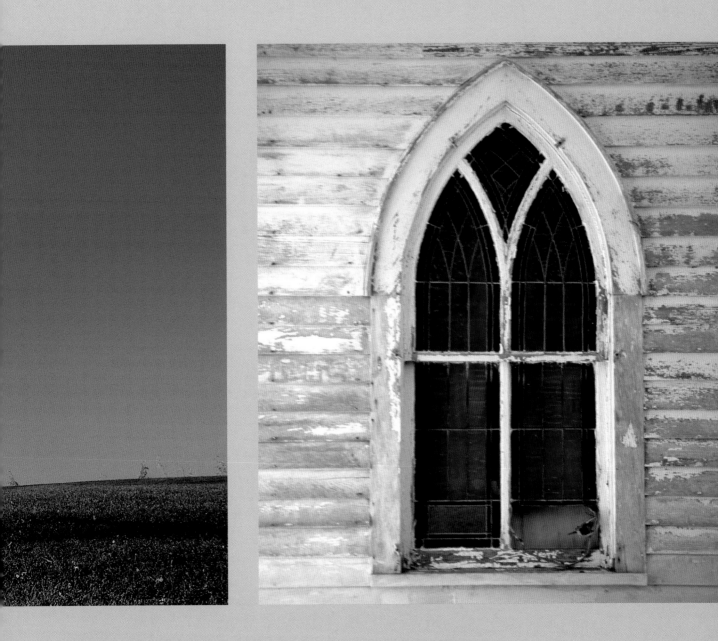

BUNDLED IN A SNOWSUIT, scarf, and blanket, I'm gliding happily along the icy sidewalk in the box sled my father has built and my mother is pulling. It doesn't occur to me that this daily trip downtown in all weather is a measure of my parents' devotion to one another; I'm only four and too self-involved to understand any but their equally strong devotion to me. I have begun to sense, however, that my father has a competitor—somebody named God—for my mother's attention, because whenever it's below zero and the north wind bites at her exposed calves (this is about five years before the first respectable woman in this town will wear slacks in public) it's always at Sacred Heart Church that we stop for a few minutes' shelter. But not in the church proper. This is the Depression, and the cost of heating the vast reaches of the upper church through a Minnesota winter is more than this congregation can afford. We enter the vestibule and descend into the whitewashed, low-ceilinged basement, where Father Donnay has fashioned an altar and brought in a variety of cast-off kneelers and pews and slatted folding chairs that creak when you squirm, and it's here my mother takes out her rosary and gives herself up to her Maker. She talks with Him, she says. So does old Mrs. Crouch, apparently, whom we inevitably find kneeling at the Communion rail with her alarm clock ticking loudly at her elbow and her tall son sitting behind her in the front pew, looking alert and idiotically happy.

These visits don't do much for my relationship with God. I don't like it down here. It's not Sonny Crouch who repels me; I can tell by his constant smile that he's harmless. Nor is it particularly gloomy in the basement, the ground-level windows are large enough to catch a good bit of the southwest-sinking sun and bounce its pink light off the far wall, where a couple of old ladies are praying in the vicinity of the votive candles. It's the ticking clock I dislike, and the tedium it measures out. It's terribly dull down here. I've had my nap and I want to be on my way. I've long since given up trying to have a conversation with God. I used to listen, but He never said anything. I'm eager to get to the grocery store and see my father in his apron. I'm hungry for the piece of candy he'll give me.

After what seems eternity we're suddenly stirred to life by the shrill alarm of Mrs. Crouch's clock—it's ten minutes before *Jack Armstrong,* which she claims is Sonny's favorite radio show. Mother knots my scarf tightly under my chin and Mrs. Crouch zips up Sonny's jacket. The two old ladies grunt and sigh, rising arthritically to their feet. These are the Macklin sisters-in-law, who come every day to pray for the repose of the soul of their brother and husband, who died, says my mother, in a farm accident. That these two women resemble each other greatly amuses my mother. The Macklins were married so long, says Mother, that Mrs. Macklin came to resemble not only her husband but also his sister. Outside, Mother joins the three women in a brief knot of gossip under the smiling gaze of Sonny Crouch. I can't stand to wait another minute. I break free and run to my sled.

27

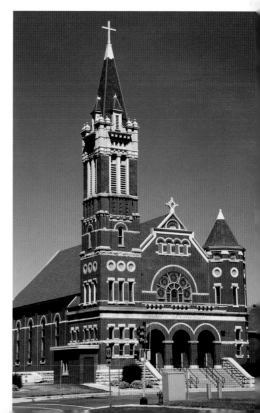

And yet now, sixty winters later, when I go back in memory to Sacred Heart, I go eagerly to the basement. It's only with effort that I picture Father Donnay and his acolytes in the upper church—at Easter, say, engulfed by the lilies festooning the raised sanctuary with its hand-carved high altar imported from France. Upstairs there's too much color and space to take in, too much mystery to puzzle over, too many people crowded into the waxed and polished pews. All but faded from memory are the gigantic and resplendent saints in the window glass and the sculpted saints looking patiently down from their niches over the side altars. Pardon me while I slip down into the basement where my initial, ascetic impression of Catholicism was formed, down under that low ceiling where the Crouches, the Macklins, my mother, and I watched the dying daylight play over the whitewashed walls, and we listened for God in the tick of the clock. ❧

BELOW Christdala Swedish Lutheran Church, Millersburg (Rice County), 1877/1878, Gothic Revival, National Register (1995)

28

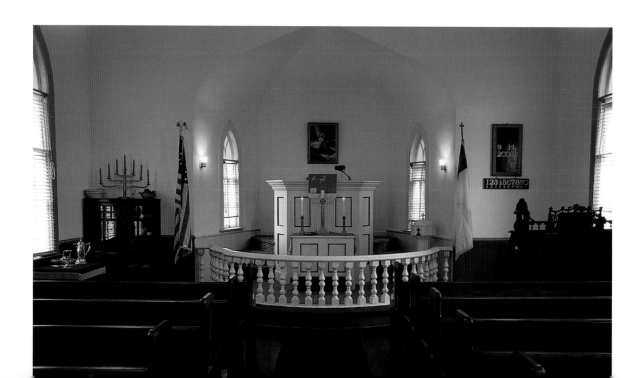

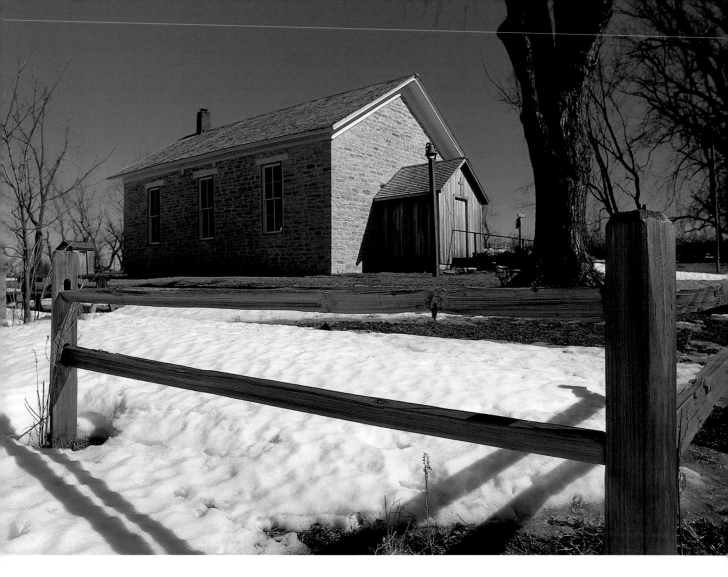

ABOVE Lenora Methodist Episcopal Church, Canton (Fillmore County), 1856–1866, Greek Revival, National Register (1982)

Lenora Methodist Church was started in 1856 by a pioneer circuit rider, the Reverend John Dyer. During its early years the congregation was hopeful that the town of Lenora—and thus the church—would continue to grow. Unfortunately, two major obstacles stifled this optimism: the start of the Civil War in 1861, and the lack of a railroad connection. The town struggled, and by the early twentieth century the church was closed. For many years it sat empty and abandoned, but today, due to the efforts of local preservationists, the church has been restored to its original condition and is being used again by local historical and religious groups.

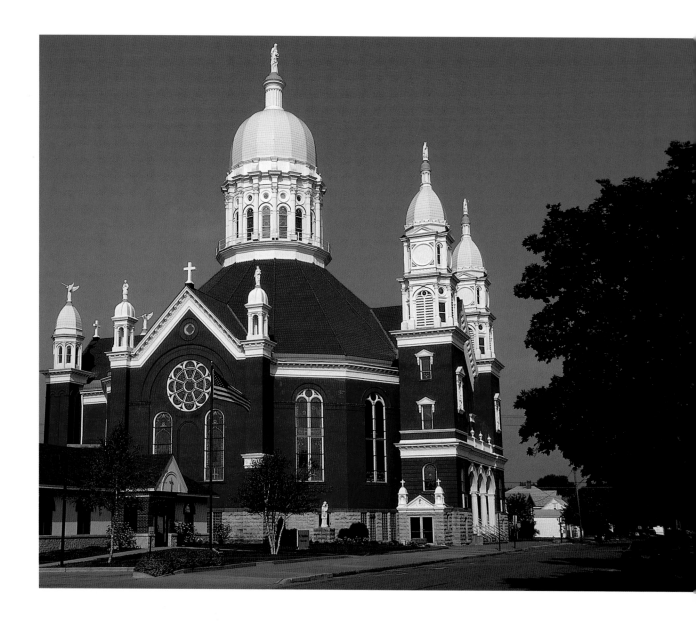

ABOVE St. Stanislaus Catholic Church, Winona (Winona County), 1872/1894–95, Romanesque Revival, National Register (1984)

RIGHT Immaculate Conception Catholic Church, New Munich (Stearns County), 1857/1911, Romanesque Revival

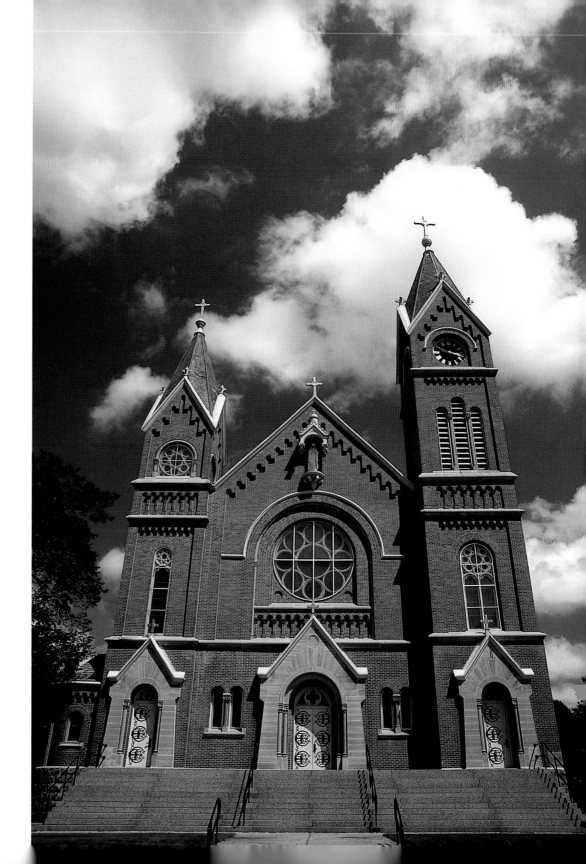

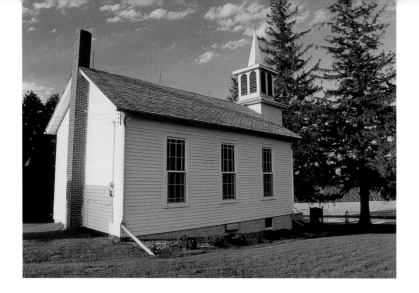

ABOVE Richland Prairie Presbyterian Church, rural Fillmore County, 1868, Greek Revival

BELOW Trinity Lutheran Church, Debs (Beltrami County), circa 1920

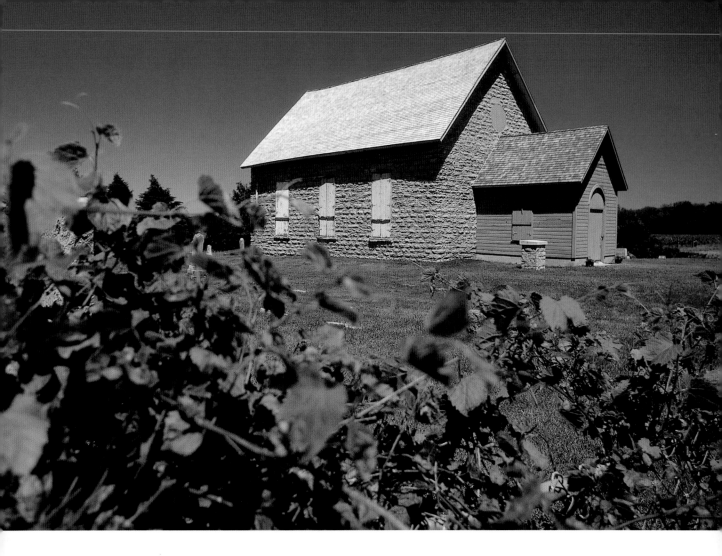

ABOVE Hauge Lutheran Church, Kenyon (Goodhue County), 1875, National Register (1980)

As the Hauge congregation was planning to build its church, the nearby Gol Lutheran congregation also began preparations to build its church. While Hauge members busily secured material and money for construction, the pastor of Gol Lutheran, the Reverend B. J. Muus, aggressively solicited donations from community members, arbitrarily setting the sums each family was expected to contribute. When he called on Ole Erickson, he asked for $200 plus stone for Gol. Mr. Erickson was willing to contribute the stone but felt that $200 was too large a sum. Offered the stone without the accompanying money, Reverend Muus refused it and angrily left Mr. Erickson's farm. When he felt calmer, however, the pastor returned and stated that he would accept the stone alone. "You're too late," Mr. Erickson informed him. "I have already promised the Hauge congregation the stone for its church." The little stone building served as the congregation's church until 1903. Today the community opens the historic structure for a special heritage service each summer.

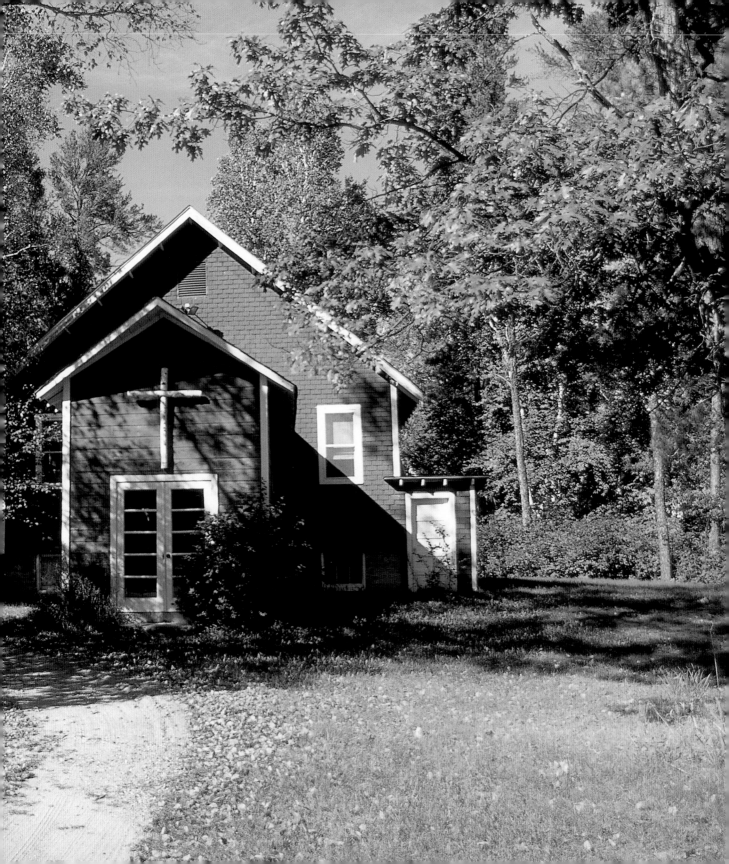

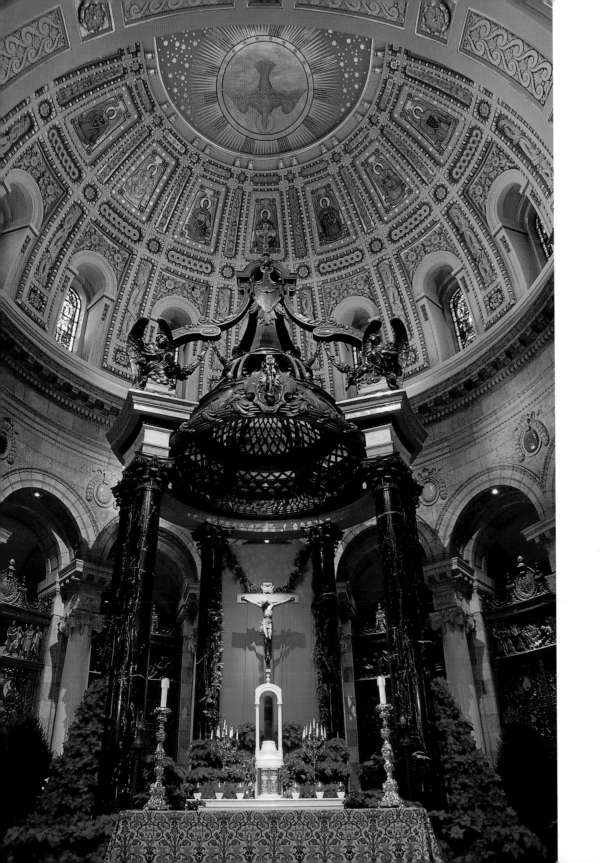

PREVIOUS PAGES Whitefish Community Church, Pine River (Crow Wing County), circa 1950

LEFT Bronze and marble baldachin, Cathedral of Saint Paul, St. Paul (Ramsey County), 1841/1906–14, Baroque, National Register (1974)

BELOW St. Henry Catholic Church, Monticello (Wright County), 1910/1999

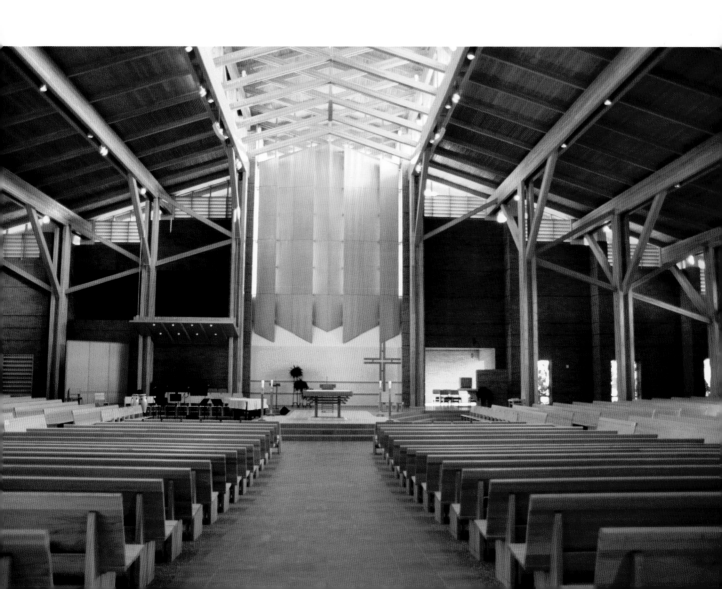

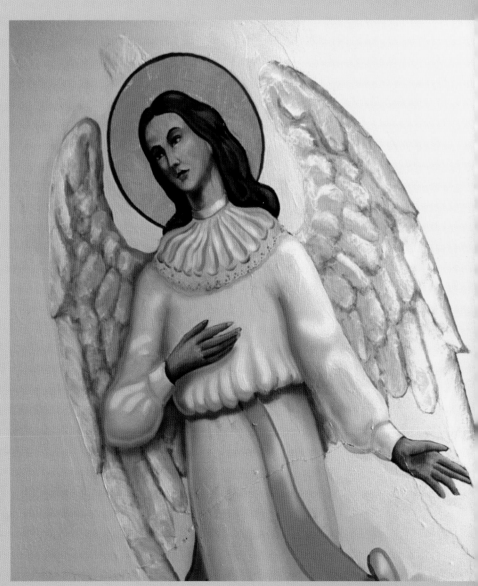

PREVIOUS PAGES:

LEFT Zion Lutheran Church,
Cloverdale (Pine County),
1921/1926

RIGHT Angel painting, St. Michael's
Catholic Church, Stillwater
(Washington County), 1853/1875

40

THE NUNS of Sacred Heart School were my teachers in the primary grades. In the first grade Sister Simona taught us the Apostles' Creed, Ramona Overby wrote me love notes, and Leo Kranski, whenever Sister was out of the room, displayed his penis. In the second grade (same room, same sister) Ricky Burke told me he'd quite smoking; Father Donnay, on his name day (December 6, the Feast of St. Nicholas), presented each of us with a small red apple; and I, on December 7 or 8, beat up Billy Shelver. What made Billy culpable, to the best of my memory, was his large vocabulary. We were playing at war in the alley between our houses, putting our toy soldiers and planes and ships through a reenactment of Pearl Harbor, when Billy, a year younger than I, uttered the word "weapons." It was a word I didn't know, so I gave him a bloody nose. I was both thrilled and terrified by the sight of this blood and tears. My memory of this event will be forever tied up with my memory of Father Donnay's apple, a frightening experience unmitigated by any sort of thrill. I carried the apple home from school and forgot it until, weeks later, I found this sacred gift turning black with rot at the back of the refrigerator. Here was a sacrilege too serious to be forgiven, and I lived for weeks with the dread of the hellfire awaiting me when I died. I might have sought consolation from my confessor if he weren't the man who'd given out the apples.

In the third grade, under Sister Constance, we went deeper into theology. Why did our guardian angels insist on remaining invisible? In fasting from solid food during Ember Days, could we have a thin milkshake? Was I guilty of a serious sin when, standing in line at the confessional, I overheard Ricky Burke

confess that he fought with his brothers? Sister was stumped by the first question, declared no to the second, and found both Ricky and me guilty in regard to the third.

I had come a long way since my impatient days when my mother pulled me to church on my sled. So what if God didn't speak to me directly; it was enough to know what the nuns taught about his existence.

There were six nuns staffing Sacred Heart Elementary in those days—one for every two grades, plus a music teacher, Sister Bede, and a housekeeper, Sister Harold. They lived across the street from the church in a crooked brick house, where, beginning in grade two, I went once a week for my piano lesson. Sister Bede was tough. She never smiled and never complimented me on my performance, and she hit my knuckles with a ruler whenever I played a wrong key, which I did fairly often because I was a halfhearted musician and seldom came to my lesson well prepared. Now that few sisters remain in parishes, I often think of those six women living out their lives that way. They seem in retrospect so dedicated, so sure of their faith—like so many other women religious—that it's no wonder we youngsters believed every word they uttered.

I was a champion believer in those days. I believed every fact, myth, and holy opinion taught me during those first years of parochial school. I believed in the Communion of Saints, the Knights of Columbus, the multiplication tables, and life everlasting. I believed in the efficacy of prayer, fasting, phonics, scrap metal drives, and war bonds. The one thing I had trouble believing was Sister Constance's prohibition of the word "leg." She said we must always say "limb" because "leg" had improper connotations. I never believed that. 🌿

LEFT Door, Holy Cross Episcopal Church, Dundas (Rice County), 1870, English Gothic Revival, National Register (1982)

BELOW Chapel doorway, St. Agnes Catholic Church, St. Paul (Ramsey County), 1887/1912, National Register (1980)

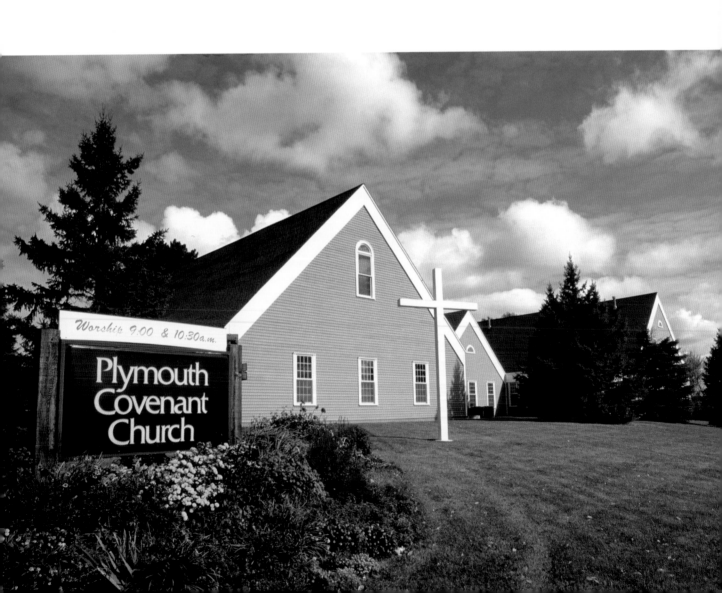

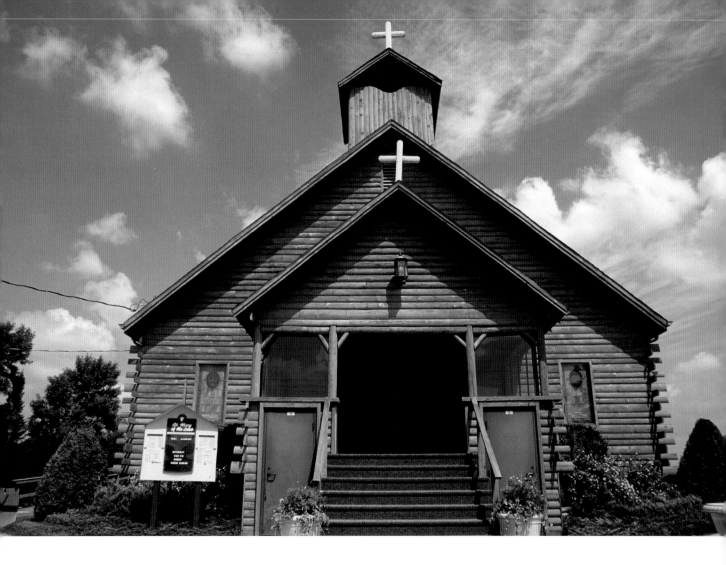

LEFT Plymouth Covenant Church, Plymouth (Hennepin County), 1974/1980

ABOVE St. Mary of the Lakes Catholic Church, Detroit Lakes (Becker County), 1940

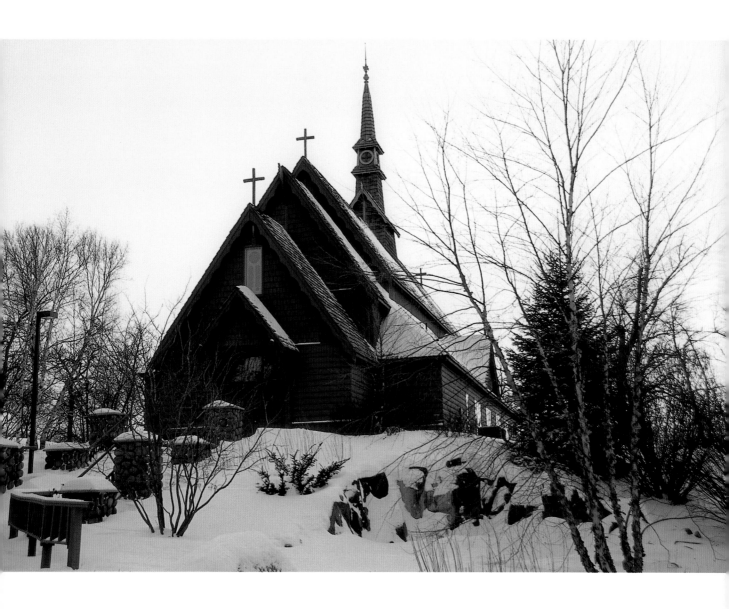

LEFT, TOP Stordahl Lutheran Church, Roscoe Center (Goodhue County), 1878/1915, Gothic Revival

LEFT, BOTTOM Zion Lutheran Church, Green Isle (Sibley County), 1871/1880

ABOVE Green Lake Chapel, Spicer (Kandiyohi County), 1940, Norwegian Stave

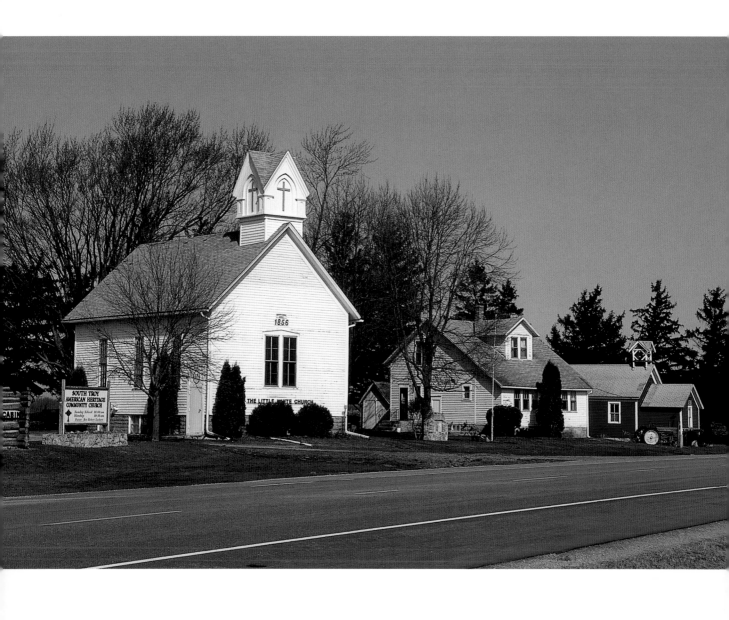

LEFT South Troy Wesleyan Methodist Church, South Troy (Wabasha County), 1882

BELOW Rice Lake United Methodist, Kiester (Faribault County), 1861, Colonial Revival

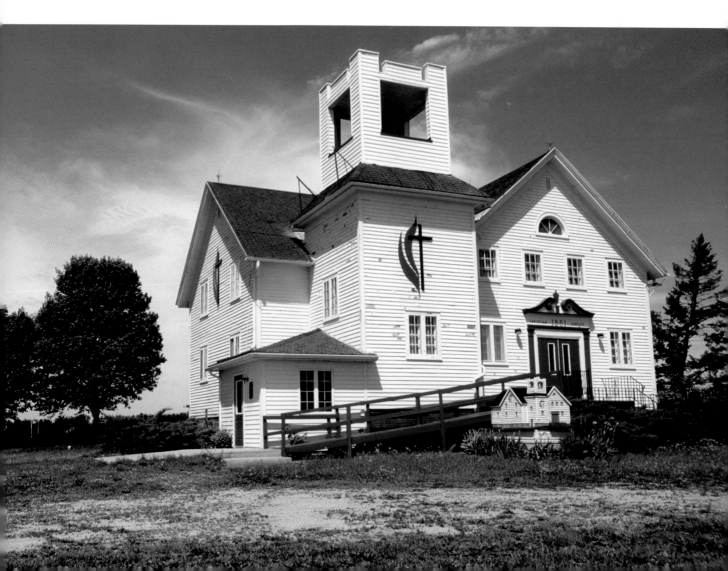

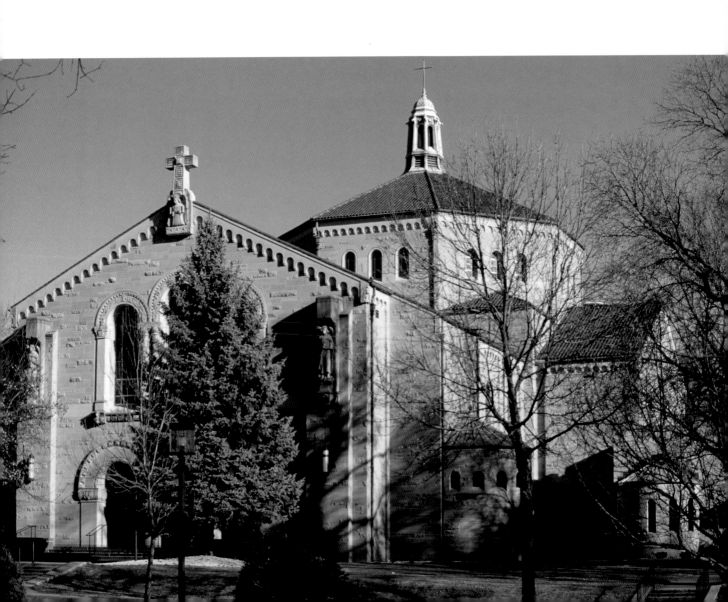

LEFT St. Charles Borromeo Catholic Church, St. Anthony (Hennepin County), 1938/1958, Byzantine-inspired

ABOVE Mount Olivet Lutheran Church, Minneapolis (Hennepin County), 1920/1939, English Gothic Revival

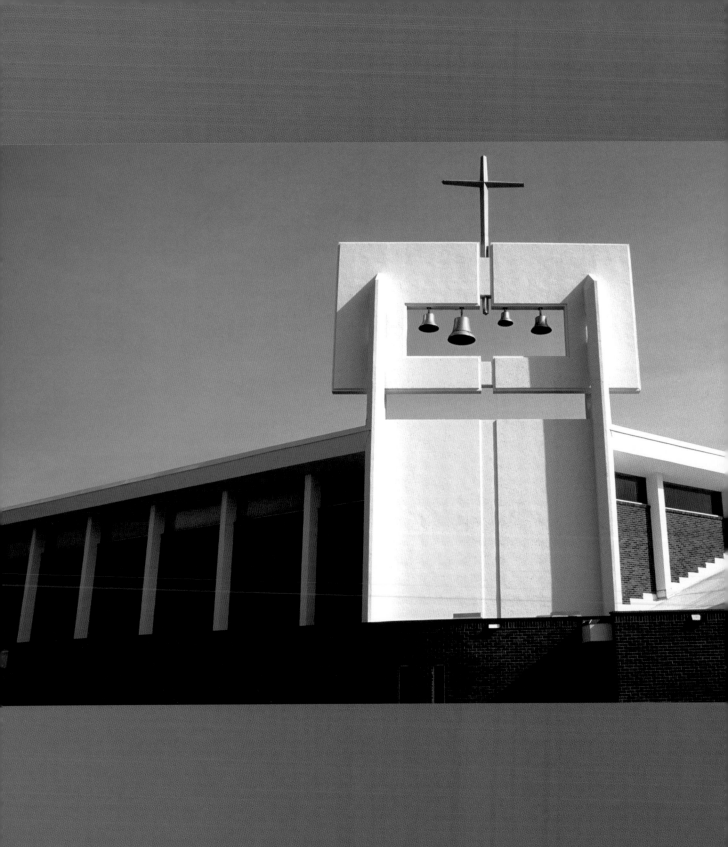

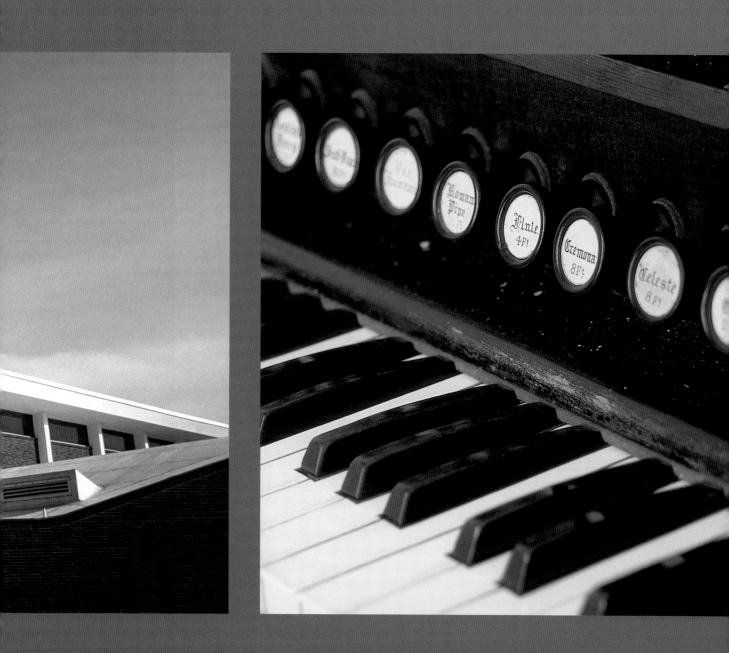

52

THEN WE MOVED. After a
decade of managing a store for the
Red Owl Corporation, my father
got a job in a munitions plant in Min-
neapolis, where we lived with my
mother's parents on South Aldrich,
a pretty avenue shaded by a canopy
of elms and all but devoid of traffic because of the wartime
shortage of tires and gasoline. Our house was a dozen long
blocks from the Church of the Incarnation, a handsome
Romanesque structure with white marble statuary standing
out against the dark brick, but without (it seemed) a base-
ment. Here, in 1930, my parents had been married, and here,
on Easter Sunday 1933, I had been baptized.

Surely our household of five went to Mass every Sunday
(a serious strain of religious devotion came down to me out
of Bavaria on my father's side of the family, out of Ireland
on my mother's side), and yet I don't recall a single Mass at
Incarnation. What I do remember are the rather sparsely
attended Tuesday evening devotions my mother and I walked
to throughout the spring and summer of 1943 (my father, on
night shift, went to work at suppertime), and how earnestly
we prayed for victory followed by world peace. I remember
the coolness of the vast empty spaces between the faithful dur-
ing May and June, and then, during August, the heat trapped
inside as the days shortened and cooled. This was the year I
came to love, under my mother's guidance, singing "Tantum
Ergo" and lighting votive candles.

This was also the year, I believe, that my sainted grand-
mother, in that very church, was refused absolution and cast
out of the confessional by a roaring priest whose name we

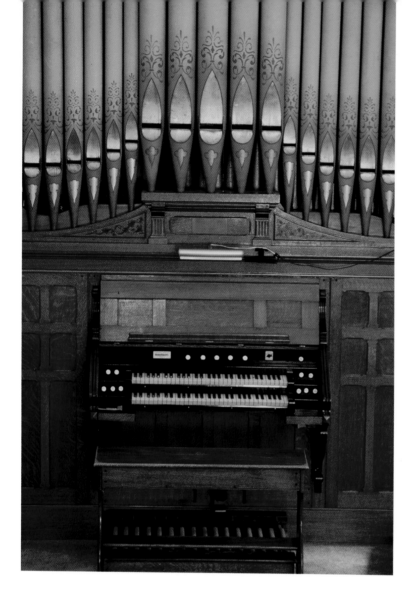

FAR LEFT Statue of David, St. Mark's Episcopal Church, Minneapolis (Hennepin County)

LEFT Organ, Vang Lutheran Church, Dennison (Goodhue County)

NEXT PAGES:

LEFT Our Lady of Lourdes Catholic Church, Minneapolis (Hennepin County), 1857, Romanesque Revival, National Register (1971)

RIGHT Church of the Assumption, St. Paul (Ramsey County), 1856/1871, Romanesque Revival, National Register (1975)

never learned and whose form of insanity we speculated about for years after we left the city. This experience, as I recall, did nothing to diminish her faith. She thought—as all churchgoers must, no matter what their religion—that as long as mere mortals were entrusted with the Divine Word, we were always liable to come in contact with priests and ministers with human faults. This grandmother, my mother's Irish mother, died about three years later on a Sunday morning as she rode a streetcar on her way to Mass. 🌿

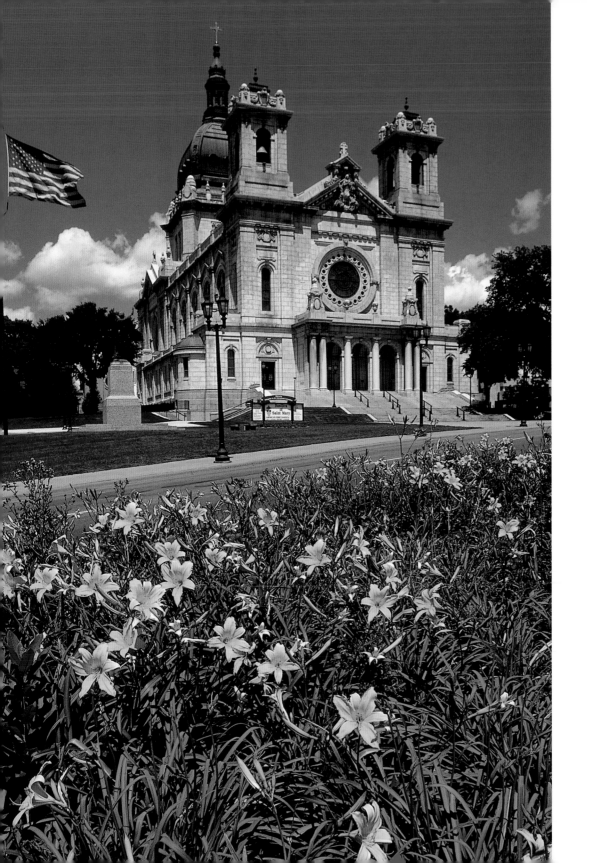

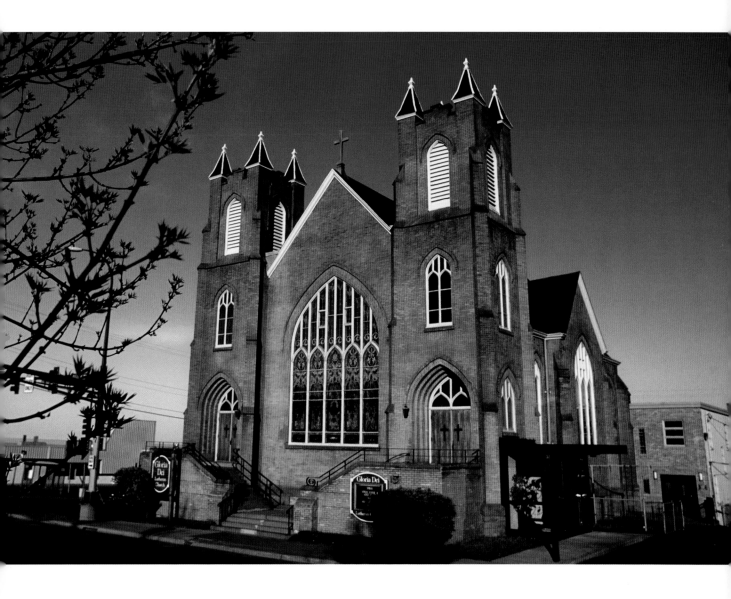

LEFT Basilica of St. Mary, Minneapolis (Hennepin County), 1868/1914, French Renaissance, National Register (1975)

ABOVE Gloria Dei Lutheran Church, Duluth (St. Louis County), 1870/1906, Gothic Revival

NEXT PAGES Our Lady of Victory Chapel, College of St. Catherine, St. Paul (Ramsey County), 1938, National Register (1985)

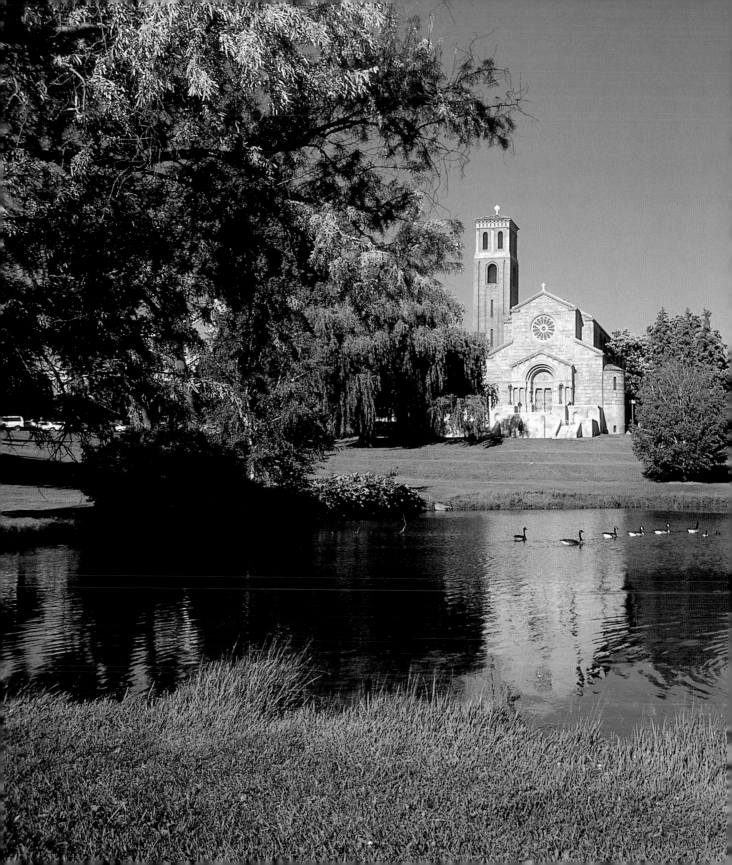

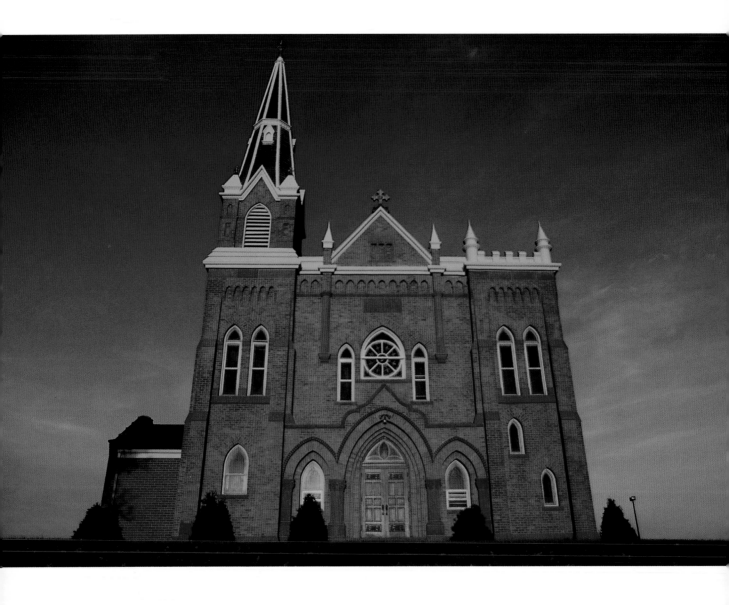

ABOVE Trinity Lone Oak Lutheran Church, Eagan (Dakota County), 1880/1902, Gothic Revival

Trinity Lone Oak Lutheran was organized in 1880 by a small group of German settlers in Inver Grove. The first services were held in the home of an early member, John Rahn, and in the local public school. In January 1881 a resolution was passed to purchase two acres of land for the building of a church, of simple frame construction, on the site of the present cemetery. The church stood for twenty years but was struck by lightning in September 1901 and damaged beyond *repair as members of "the bucket brigade . . . failed in their effort to save this loved house." Less than a year passed between the disaster and the laying of the cornerstone to the second and present church. Originally all services were conducted in German, but by World War II English was the standard. The church received its name from a nearby tree, a symbol of strength, character, and historical significance.*

BELOW Lakewood Cemetery Memorial Chapel, Minneapolis (Hennepin County), 1908–10, Byzantine, National Register (1983)

NEXT PAGES, LEFT Bell tower, St. Olaf Catholic Church, Minneapolis (Hennepin County), 1941/1955

NEXT PAGES, RIGHT Church of St. Columba, St. Paul (Ramsey County), 1914/1949, French Norman

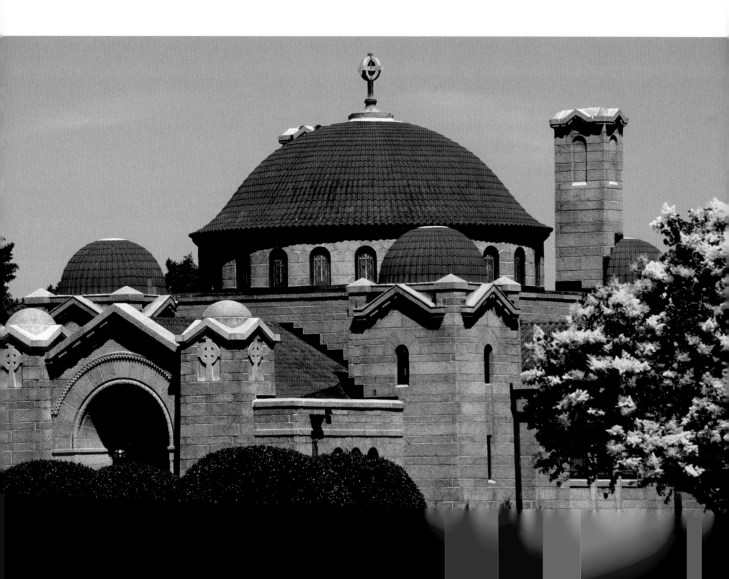

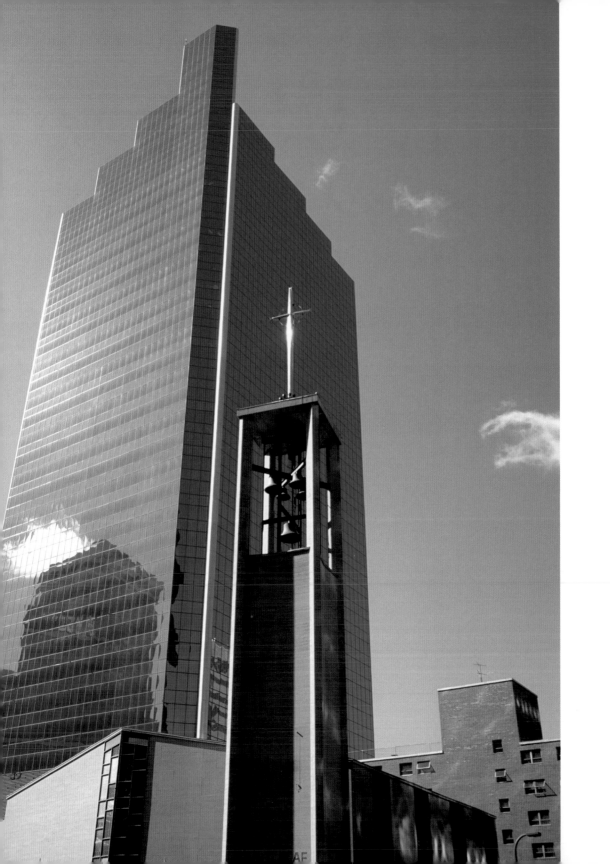

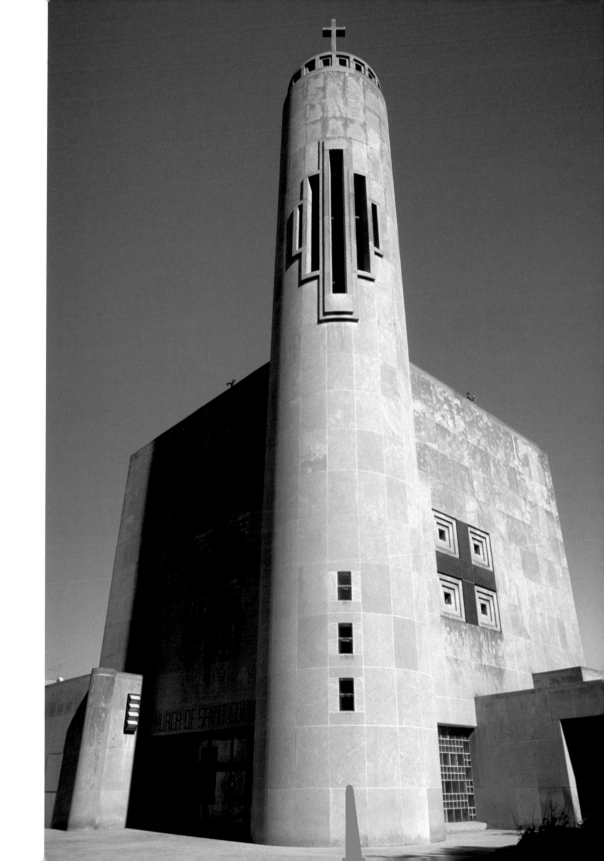

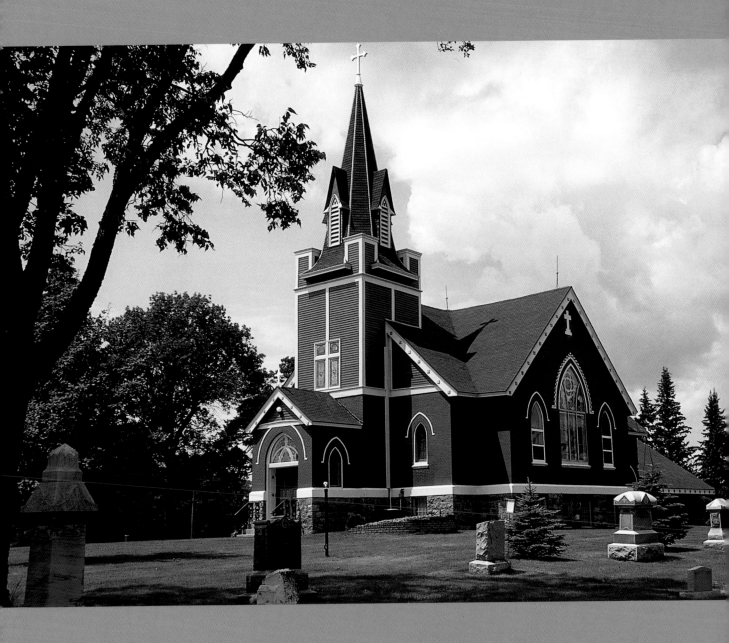

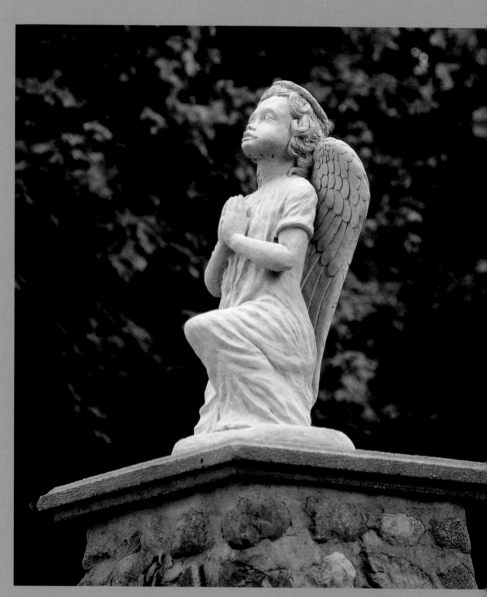

PREVIOUS PAGES:

LEFT Eksjo Lutheran Church,
Lake Park (Becker County),
1871/1901, Carpenter Gothic

RIGHT Angel statue, Holy Trinity
Catholic Church, Waterville
(Le Sueur County)

AFTER LESS THAN A YEAR in Minneapolis, we moved to a village surrounded by fields of corn and cattle, where my parents had purchased a Red Owl store of their own. Within a month of our arrival in town, and completely untutored, I began to serve Mass at St. Joachim's. This being a nunless parish and its old and ascetic pastor, Father O'Connor, being too far removed from the mundane to bother instructing a mere child of ten, I apprenticed myself to the only other server in the parish, a boy named Jackie.

Jackie was the good-natured youngest child of a widow who cleaned houses for the two or three well-to-do families in town. He was two years older than I, and the object of my great admiration, not only because he was a faultless altar boy—dedicated, devout, punctual, and obedient—but also because he seemed smarter than a lot of Catholics I knew, and he had a wry sense of humor. (At this point in my life, it seemed to me that I had met, among the truly religious, an overabundance of humorless types, and I had begun to wonder if slowness of mind might be a prerequisite to holiness.) Whenever Father O'Connor lost his way in the pulpit and followed an irrelevant path into private musings, Jackie would turn his wise little grin in my direction as if to say "How pathetic," and hope, I'm sure, for an answering grin from me.

Outside of church, however, we saw very little of one another—such is the gap between a fifth grader and a seventh

grader—and yet, when at the end of our first year in town we moved from the stockyards neighborhood to a house near the athletic field and I found myself living just a few doors down the block from Jackie, I imagined we might become chums at last. But it was too late for that. By this time Jackie was dying.

I was perhaps his only regular visitor. I went every Saturday after lunch. His mother had converted the front room of their small house into Jackie's bedroom, so he could watch the passing traffic on Highway 42 from his bed. What did we do or say during my visits? We may have played a hand or two of rummy, and maybe we looked over the assignments I brought him from his homeroom teacher, but I have no memory of anything but making small talk. It's a characteristic of anyone growing up in a happy household, I've found, this ability to wring every possible remark out of an unremarkable topic. Around people we're fond of, our urge to converse is far greater than our need to do so, and therefore we talk at length about little, stringing out our words the way spiders emit the filament of their webs. In the grocery store, imitating my parents, I was growing proficient at small talk, particularly with old people, and Jackie was about as old as he was going to get.

At first I went to see him under orders from my mother. Visiting the sick was a corporal work of mercy, after all, and she was eager for me to start building up some credit in eternity. Besides, rheumatic fever, unlike polio, was said to be non-contagious. But soon I found myself making these weekly visits of my own accord, for I was finding more and more about Jackie to be fond of. "This seeing the sick endears them to us,"

BELOW Pews, Fish Lake Lutheran Church, Harris (Chisago County)

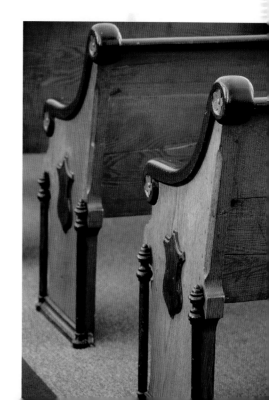

says Gerard Manley Hopkins, and of course it's true. He seemed to be changing. He was going through the same shrinking stages we witness now and then in a public figure who will allow himself to waste away on the television news—recently Pope John Paul II, Vice President Hubert Humphrey twenty years ago—but I'm not talking about this physical transformation so much as a change from within. His illness seemed to relax him. It had a kind of purifying effect on him, taking away his tendency to be ironic and leaving in its stead the sort of transparency through which I could see quite plainly the sweetness that permeates the soul of a saint.

One sunny day in late autumn, for example, gazing out the window of the front parlor that had been converted into his bedroom, Jackie's eyes settled on the distant athletic field and he remarked, "I can see you guys playing football over there after school." He said this without a trace of envy in his voice, no hint of anguish or despair. Whereas I, with my obsessive love of football, would doubtless have been bitterly frustrated in his position. Jackie seemed to be speaking out of sheer pleasure.

Or again: his older sister's husband, dismayed by Jackie's loss of weight, stopped by with a quart of ice cream one day and demanded he eat all of it nonstop. This was shortly before my arrival, and I found Jackie looking bloated and amused as he slowly spooned up the last of the ice cream. His brother-in-law stood over him, looking smugly full of himself—believing, I suppose, that he'd just discovered the cure for rheumatic fever. And Jackie's sublime smile said that he believed it, too,

but of course this was for his brother-in-law's benefit only, for when he turned to look at me, I saw a flicker of the old wryness in his eyes. "We'll get some meat on that kid's bones yet," the brother-in-law explained to me on his way out. "I'm coming back tomorrow with another quart." With his savior safely out of the way, Jackie asked me to bring him the basin from the drainboard in the kitchen, then he asked me to please go outside and come back later. As I left, I heard him begin to vomit.

God knows how many quarts of ice cream Jackie put down and later brought up in order to sustain his brother-in-law's hope. I only know that the more I saw of Jackie's self-abnegation, the more fascinating it became. Wasn't this the sort of God-pleasing humility the Church of Rome had been urging on me since the first grade? But with this difference: Jackie wasn't being humble for God's sake, or the Church's, or even his brother-in-law's; he was being simply himself.

Here, then, was virtue in its pure form, and I found it every bit as attractive as the evil bent of Timmy Musser, the conniving kid in town who had the instincts of a hardened gangster and who always seemed to be plotting his next heist. I longed to be as good as Jackie, and yet, at the tender age of ten or eleven, I somehow knew that to reach Jackie's level of virtue, I would need to drop my pride, my self-regard, the very idea that I was being virtuous. I was much too self-aware to be as good as Jackie.

Or as bad as Timmy Musser, for that matter. For isn't it this same lack of self-regard that allows the thief or the terrorist to

LEFT St. Mark's Episcopal Church, Annandale (Wright County), circa 1870

ABOVE Cross and bell banner, St. John's Abbey Church, St. John's University, Collegeville (Stearns County), 1875/1954

carry out his mischief? No, I would never be a candidate for sainthood or prison. With my proclivity for patient watchfulness, I would always play the role of bystander. I could thrill to tales of derring-do, and I could admire goodness, but I'd never come close to either end of the scale.

Jackie died, and I made one last trip to his house, this time in the evening, with my parents, to view the body. We found the kitchen crowded with Jackie's brothers (one in uniform) and mother and sisters and their families. Jackie, in his coffin, had the front room practically to himself while we the living

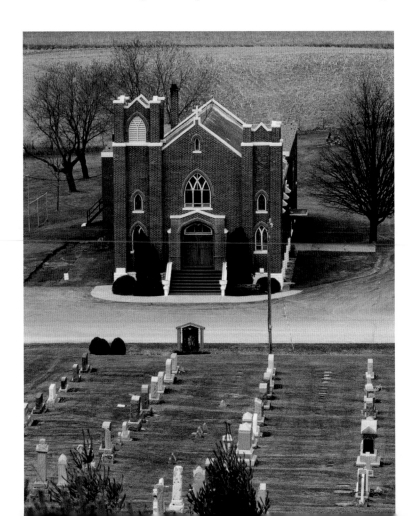

ate his mother's homemade cookies and made cheery small talk. We were reluctant to leave each other's company for more than the few seconds it took to step through the open doorway and mumble a prayer. I didn't do even that. I, who had given him a part of every week for several months, had no time for him now.

It was a dark, rainy morning when most of the eighth grade, and I from the sixth grade, were released from class and hurried down the street to St. Joachim's, where I put on my black requiem cassock and my white surplice, and then, bearing the crucifix on a staff, I led Father O'Connor down the middle aisle to meet the coffin and the drenched mourners in the vestibule. After the priest's prayer and a sprinkling of holy water, I turned around and led the procession into the crowded church as the organ and choir broke out in their lament. But more sorrowful than the organ and choir was that other noise we heard whenever there was a pause in the music—the relentless pounding of rain on the roof.

I didn't feel the sting of Jackie's death that day. I was too full of myself as an altar boy, imagining how I must look to my schoolmates, particularly the Protestants and the nonchurchgoers. How admirably I went about my duties at the altar, how amazing and mysterious were the phrases I cried out in sharp contrast to Father O'Connor's mumbled prayers. "Dominuuuuu vobiscuuuuuu," droned the priest. "ET CUM SPIRITU TUO!" shouted I, eleven years old and St. Joachim's lone surviving altar boy. That's nothing, folks, just wait till

LEFT St. Peter's Lutheran Church, Belvidere (Goodhue County), 1873/1925, Gothic Revival

ABOVE Statue, Holy Trinity Catholic Church, Waterville (Le Sueur County)

we get to the cemetery and I display my mastery of the sprinkler and censer.

There was rainwater standing in the grave. Although nobody mentioned it afterward, there must have been others besides me who were secretly horrified to think of lowering Jackie into eight or ten inches of chill water. And he'd better be lowered soon, before the grave filled itself up with the small mudslides that were coming loose around its perimeter. When the priest finally finished commending Jackie to God, he closed his wet book, and I handed him the sprinkler. He mixed a couple shakes of holy water with the raindrops drumming on the coffin. Then I handed him the censer, which he waved in the direction of the grave as though it still held fire. Then a mighty gust of wind swept the cemetery with a fresh squall of rain, prompting most of the mourners and schoolchildren to run for their cars while the undertaker, with the help of Jackie's brothers and brothers-in-law—no time for decorum now—dropped the coffin into the grave. That's when it finally hit me—the finality of Jackie's death—when the coffin, hitting bottom, made a splashing noise. ❦

BELOW St. Mary's Catholic Church, Geneva (Freeborn County)

RIGHT St. John the Evangelist Catholic Church, Union Hill (Le Sueur County), 1860/1883, Gothic Revival

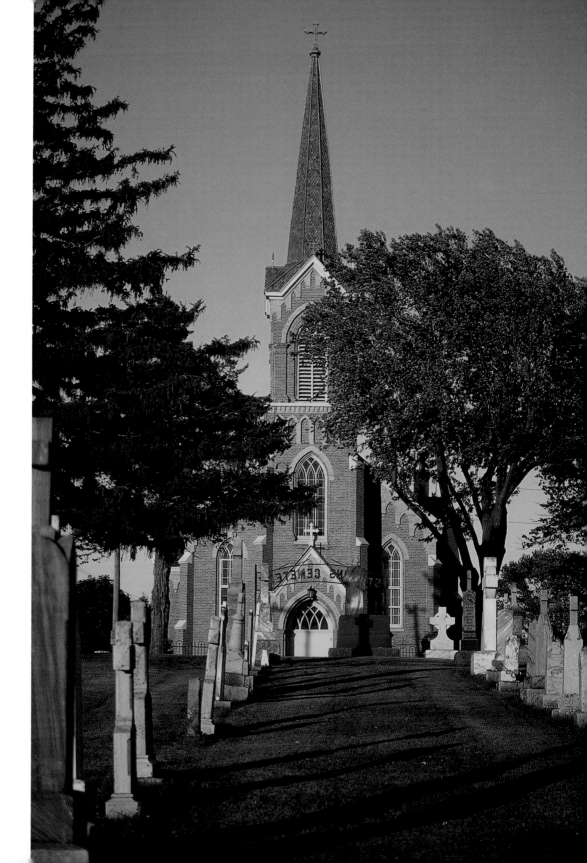

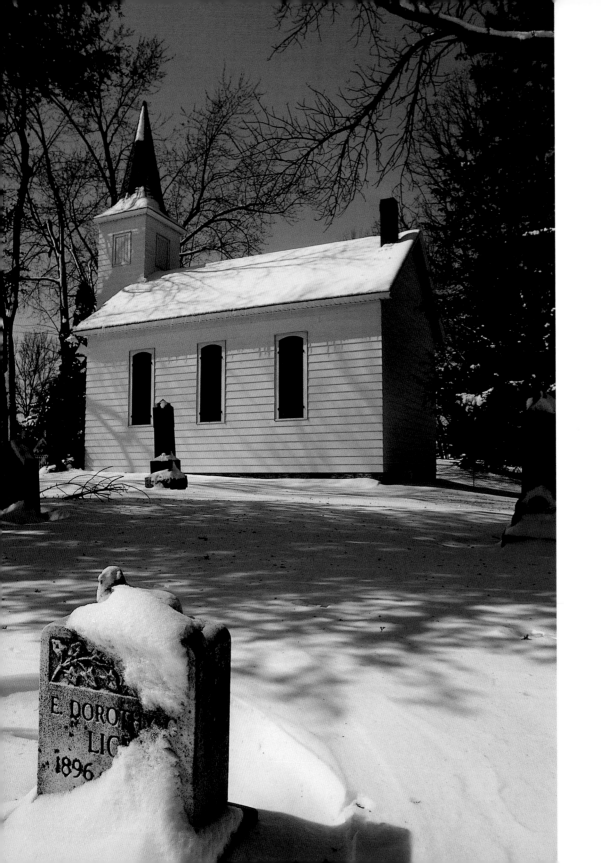

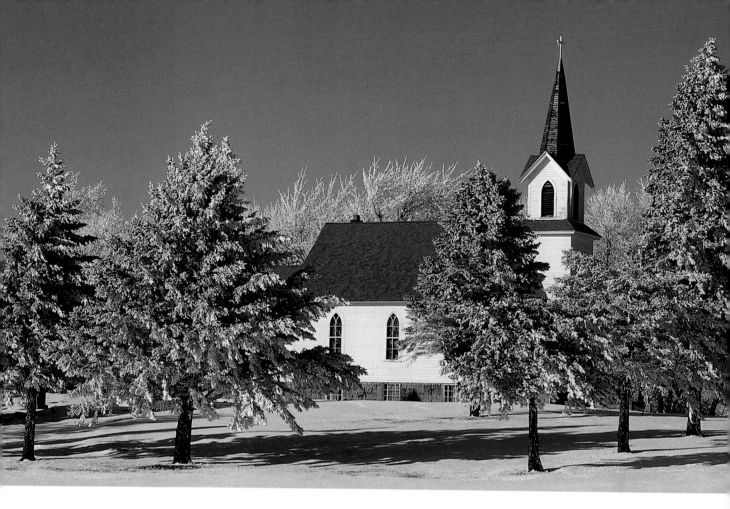

Salem Evangelical Church, Inver Grove Heights (Dakota County), 1857/1875

Salem Evangelical Church was the first Minnesota congregation of the Evangelical Association of North America. The church was organized on March 2, 1857, by the Reverend Andrew Tarnutzer. In 1875 the current building was completed, and it was used until the last recorded meeting, *on January 8, 1910. Since then, the church building has exchanged hands several times. Now home to the United Methodist Church, it stands as an early example of a country church amidst the growing suburban community of Inver Grove Heights.*

Palmyra American Lutheran Church, Hector (Renville County) 1878, Gothic Revival

NEXT PAGES Abandoned rural church (Stevens County), circa 1900, Gothic Revival

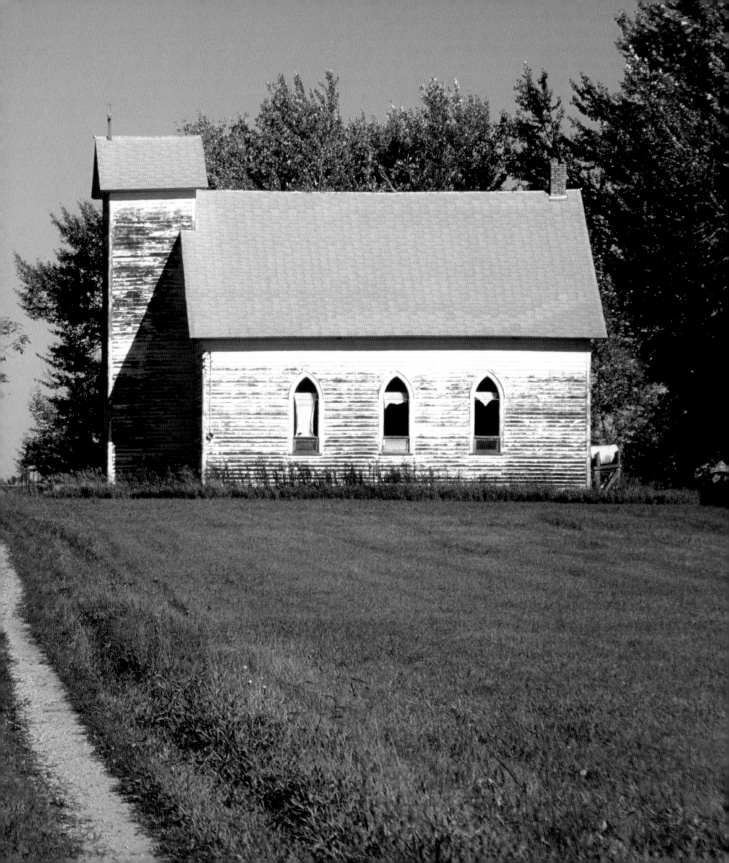

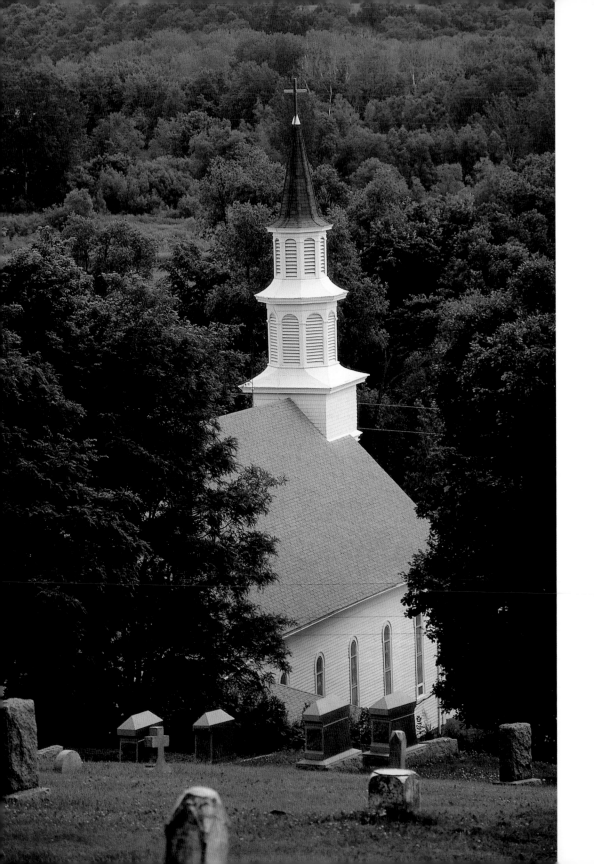

LEFT St. Thomas Catholic Church, Jessenland (Sibley County), 1853/1870, Romanesque Revival, National Register (1991)

BELOW St. Bridget's Catholic Church, Simpson (Olmsted County), 1859, Romanesque/Gothic Revival

NEXT PAGES, LEFT East St. Olaf Lutheran Church, Rock Dell (Olmsted County), 1856/1908, Carpenter Gothic

NEXT PAGES, RIGHT Richwood Lutheran Church, Westbury (Becker County), 1883, Gothic Revival

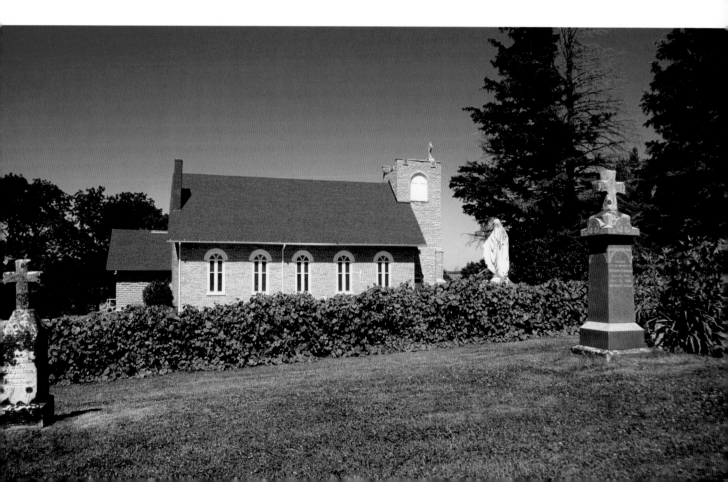

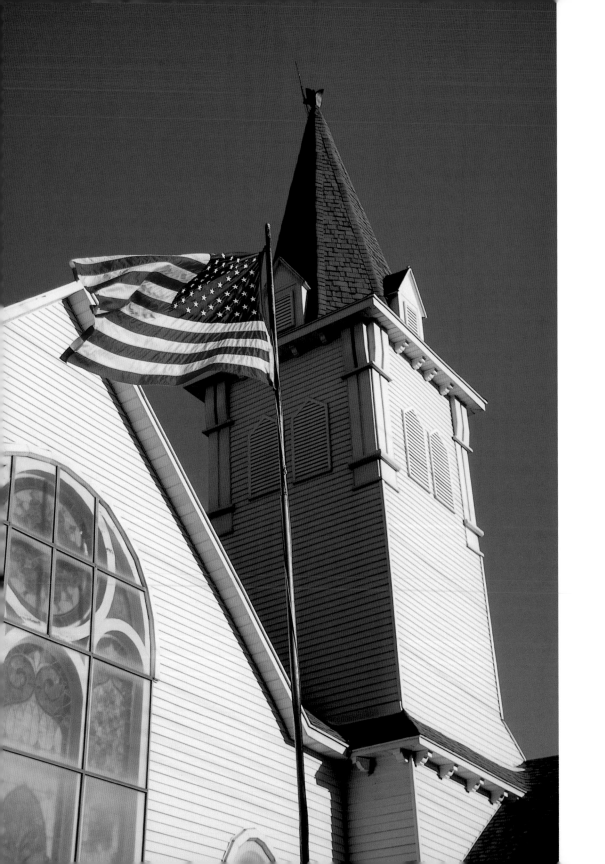

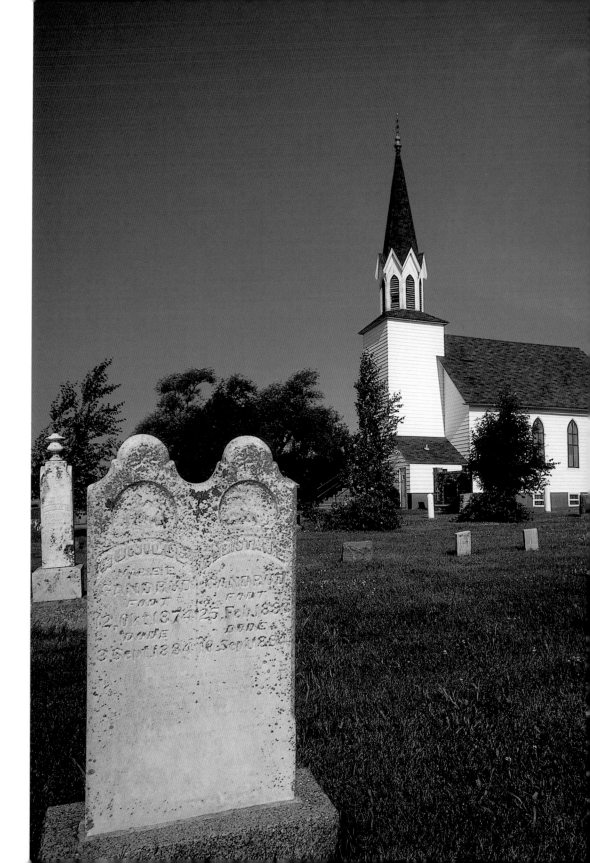

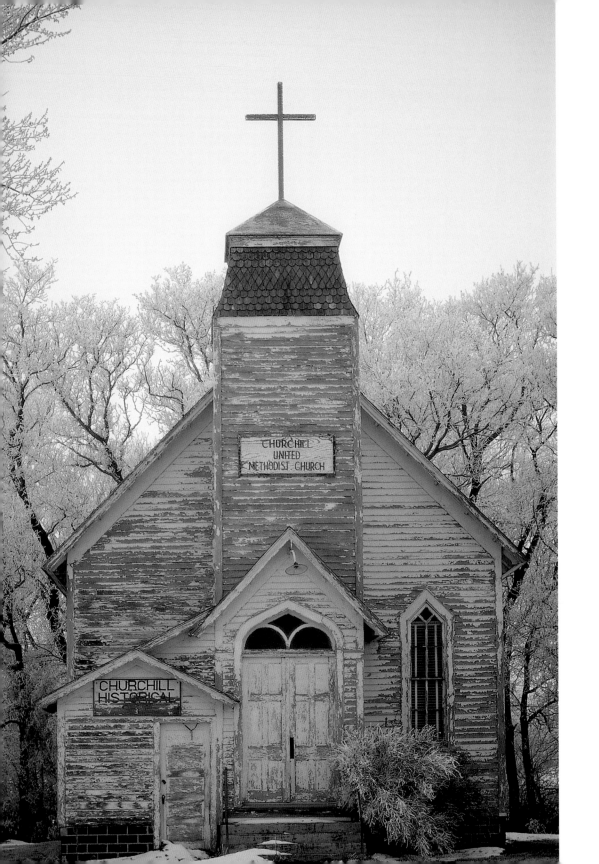

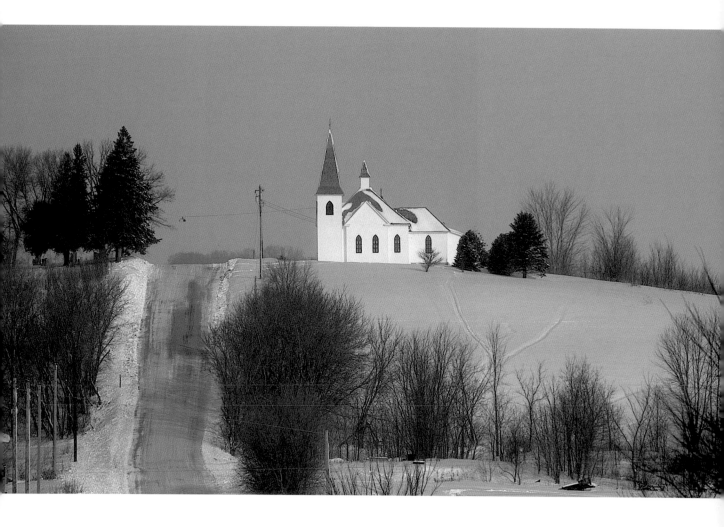

LEFT Churchill United Methodist Church, Churchill (Renville County), 1876, Gothic Revival

ABOVE Trondhjem Lutheran Church, Lonsdale (Rice County), 1876/1898, Carpenter Gothic, National Register (2001)

"I recall coming to church via sleigh in the wintertime and wagon or buggy in the summer. The pastor came by train to Lonsdale where we would meet him and he would stay with us until Monday. During the weekend there would be confirmation classes, Ladies Aid, worship services, and other activities. Remember he came only every third Sunday.

"My earliest recollection of being in this church is from a Sunday School Christmas program when my sister, Alice, *and I (ages 6 and 5) walked hand in hand to the front of the church to the Christmas tree and sang (in Norwegian of course): 'I am so glad each Christmas Eve.' The tree was lit with live candles and the church was packed with people. Following the program a bag of nuts, candy, and an apple was given to all the children."*

CLIFF M. JOHNSON, *longtime member of Trondhjem Lutheran Church*

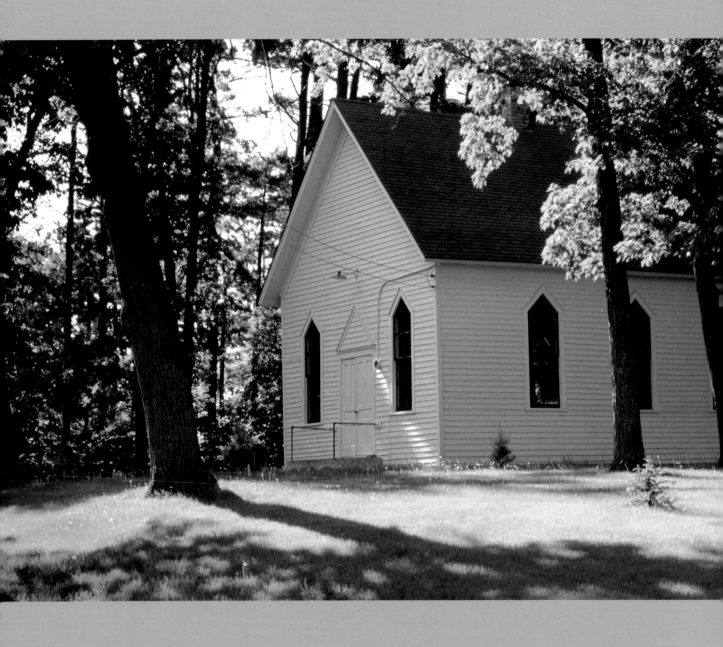

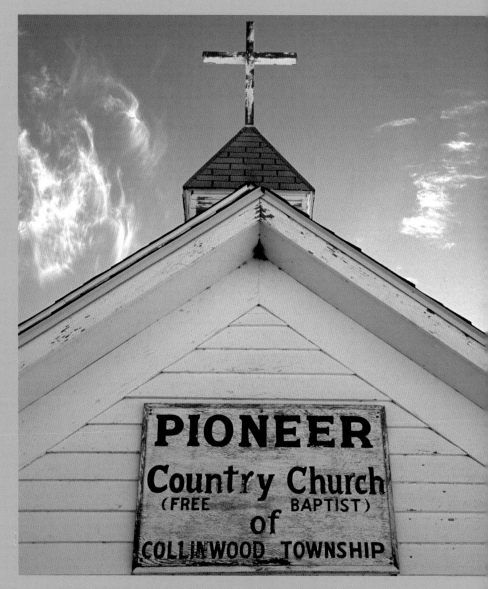

PIONEER
Country Church
(FREE BAPTIST)
of
COLLINWOOD TOWNSHIP

PREVIOUS PAGES:

LEFT South Maple Ridge Covenant
Chapel, rural Isanti County, 1884/1897

RIGHT Pioneer Country Church
of Collinwood Township,
rural Meeker County, 1893

RESERVED
FOR
PASTOR

U.S. MAIL

SUMMERS, during my high school years, I was the parish groundskeeper, for my parents by that time had purchased, for $110, the first postwar power mower seen in that town, a magnificent, self-propelled, reel-type Toro, green and yellow and heavy as an army tank. I began by cutting a few lawns for our neighbors, an enterprise my parents encouraged in order to keep me busy during the slow weekdays when most of the farmers and their families were busy in their fields and trade in the store was slack, and before long, I found myself cutting and trimming not only the wiry grass around the church and the rectory but the wild groundcover of the cemetery as well. And every Saturday morning from early May until Labor Day, I knocked on the door of the rectory, which Father O'Connor kept hermetically sealed against the summer heat, and I stood there until an inner door opened and then the front door and finally the porch door, and the old priest looked down at me in his distracted manner and said, "Yes?"

"I've come for my pay, Father."

"Ah, the grass," he said, his cold blue eyes momentarily alight with a glimmer of recognition, and I followed him into his office, where he sat down at his desk, put on his glasses,

opened the parish checkbook, dipped his pen in an ink bottle, and asked me—I swear to God—the same question week after week, year after year: "What's your name?"

Odd as it may seem, I wasn't bothered by this man's detachment. After all, hadn't I been brought up to think of religion as a kind of secret room the individual entered to find his God, and wasn't one's parish priest merely the faceless mortal who unlocked the door? He was holy, to be sure, and smart enough to learn all that Latin, but a mortal like the rest of us and easy to overlook when you were communing with the Being that created him. And, besides, wasn't this the demeanor of all priests? Wasn't the aloof Father Donnay, the pastor of my childhood at Sacred Heart, seen only at morning Mass and never in the chapel in the basement?

No, as it turned out, this wasn't the demeanor of all priests, or ministers, for that matter. I later met priests who were not detached but very affable. I think, for one example, of Father Monroe, in Fosston, Minnesota, where I taught high school English for three years and lived next door to the Catholic rectory. He was a humble, good natured, recovering alcoholic, who several times picked me up and drove me to his mission parish in Mentor, some twenty miles to the west. I don't remember what we talked about—it was fifty years ago—but I do remember the bond of friendship that developed between us. 🌿

LEFT Parking sign, St. Mary's Catholic Church, Geneva (Freeborn County), 1859/1892

BELOW Stone grotto at St. Columbkill Catholic Church, Goodhue (Goodhue County), 1860/1882

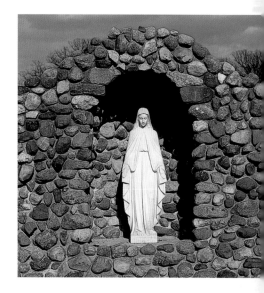

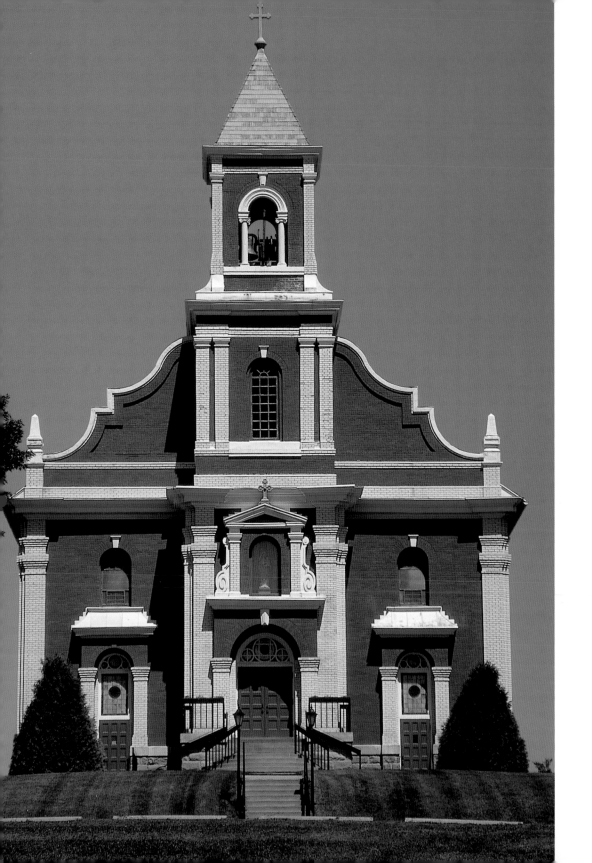

St. Mary's Catholic Church, New Trier (Dakota County), 1856/1909, beaux arts, National Register (1979)

Mass was first conducted by Father G. Keller in a log cabin on May 8, 1856, and soon after the small group of German immigrants organized the parish of St. Mary and began meeting in a log chapel. Outgrowing the chapel, they built a stone church in 1864. It served until 1909, when the present church—one of the finest examples of beaux arts church architecture in the state of Minnesota— was completed.

Ottawa Methodist Episcopal Church, Ottawa (Le Sueur County), 1859, National Register (1982)

Hutchinson Episcopal Church, Hutchinson (McLeod County), Gothic Revival

St. Paul's Episcopal Church, Belle Creek (Goodhue County), 1854, Gothic Revival

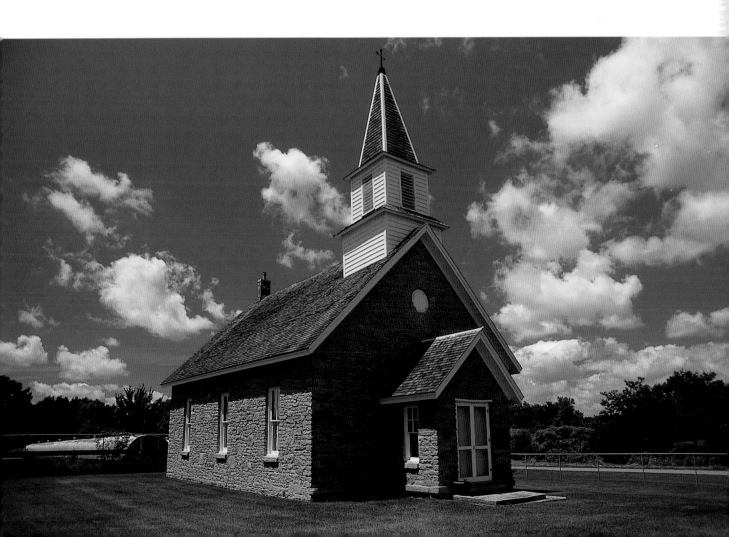

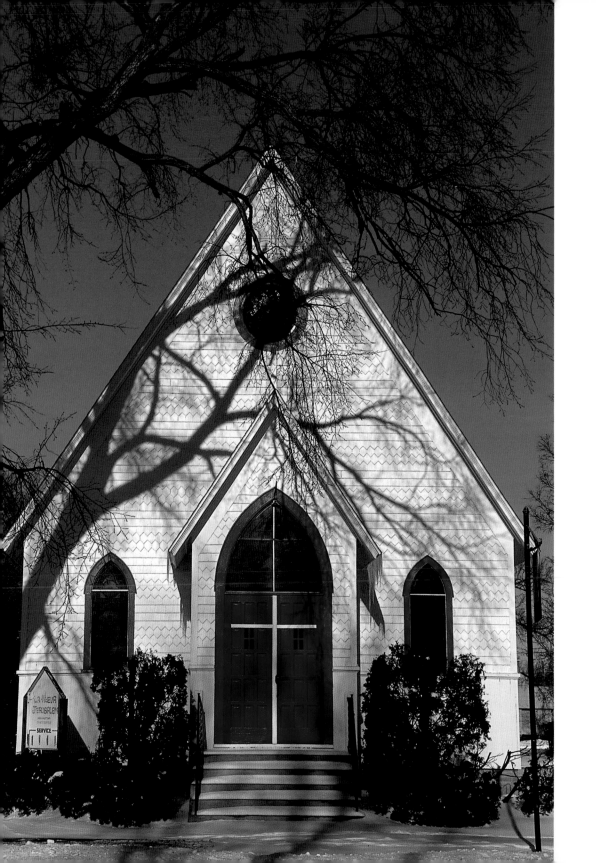

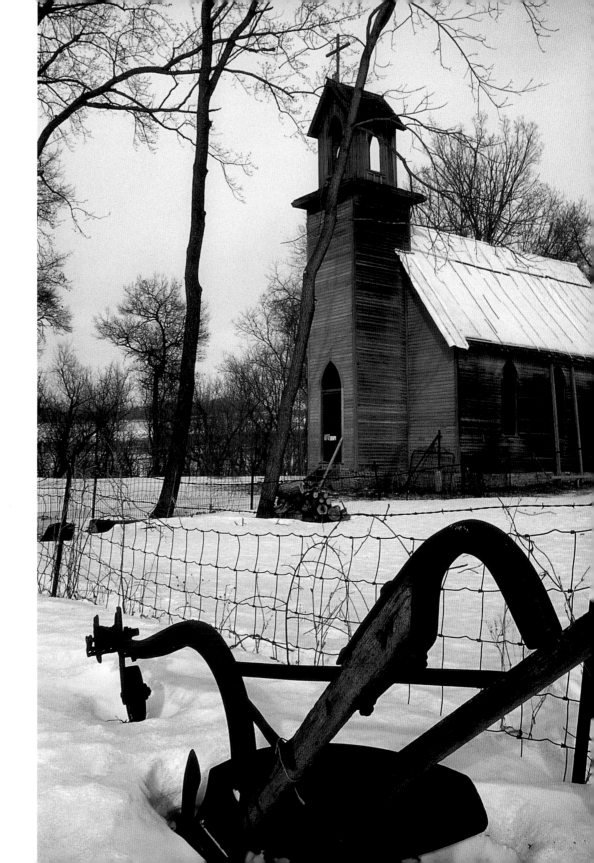

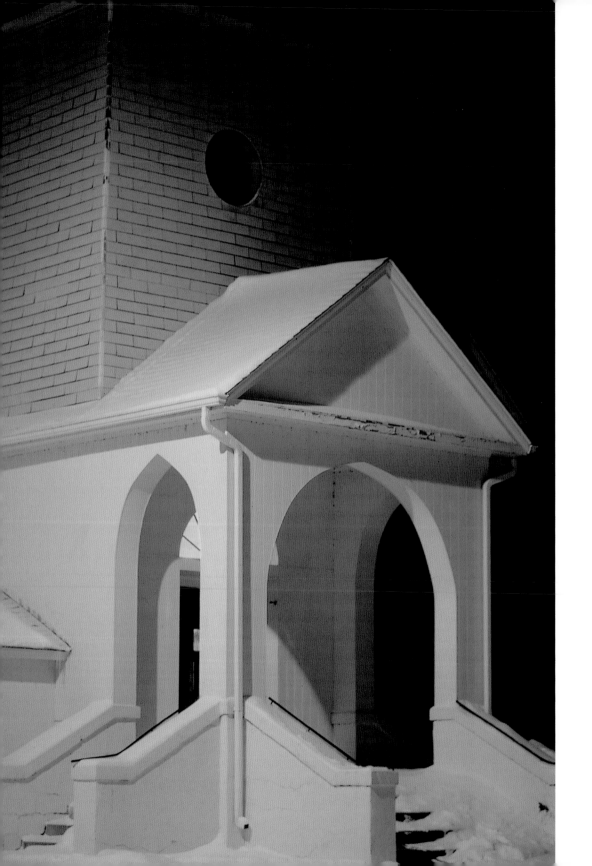

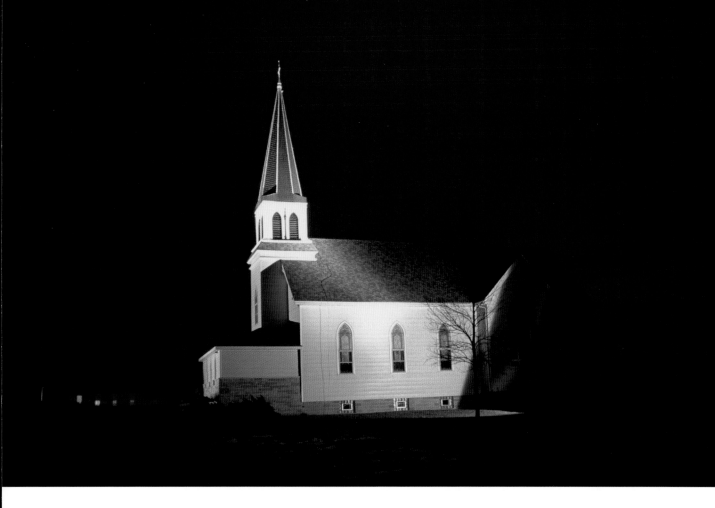

ABOVE St. John's Lutheran Church, Hollywood (Carver County), 1865/1886, Gothic Revival

LEFT Holy Family Catholic Church, Belle Prairie (Morrison County), 1852/1880, Romanesque

Father Pierz, a pioneer missionary of northern Minnesota, visited Belle Prairie at irregular intervals, but whenever he arrived he would ring the church bell to announce that he had come to celebrate Mass. One cold winter evening, overcome by a raging blizzard on his way to Belle Prairie, Father Pierz fell exhausted and was soon buried under the snow. Mysteriously, the bell rang. Neighbors came to the church to hear Mass, but the building was locked. Investigating the surrounding area, they found Father Pierz half-frozen in the snow. Father Pierz told them that he had not rung the bell, and the parishioners agreed none of them had either. In the end they decided that a guardian angel rang it to save the zealous missionary's life.

ABOVE St. John's Lutheran Church, Hollywood (Carver County), 1865/1886, Gothic Revival

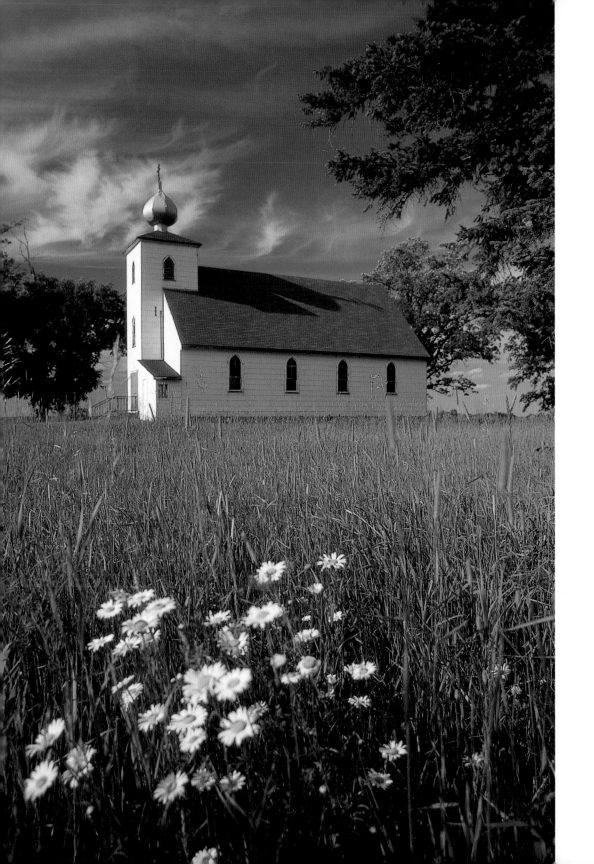

LEFT **St. Mary Church of Two River, Elmdale (Morrison County), 1902**

BELOW **St. Peter's Lutheran Church, Caledonia (Houston County), 1861/1896, Gothic Revival**

St. Peter's got its start like many early rural churches — as a Sunday School Society. Services began in a schoolhouse in 1861. During the Civil War, as many local men engaged in distant battles, the congregation struggled to maintain attendance. The church was known in those days as the Union Christian Church but later became denominational. In 1870, the first church building was constructed in simple frame style, measuring 22 by 40 feet and located on the site of the present building. In 1895, St. Peter's congregation suffered a severe setback when its building, together with all the church records, was destroyed by fire. Within a year the congregation rebuilt, and the present building served the small German community for ninety-two years. In 1988, with only six families remaining on it rolls, St. Peter's Lutheran closed its doors.

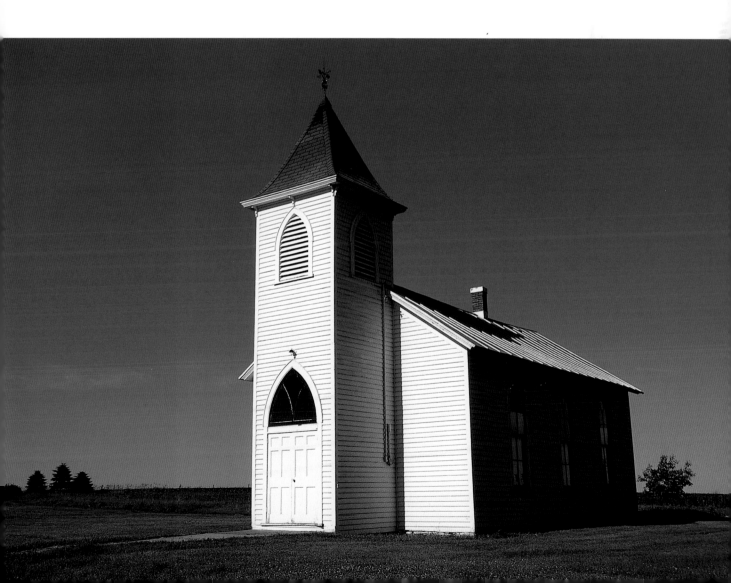

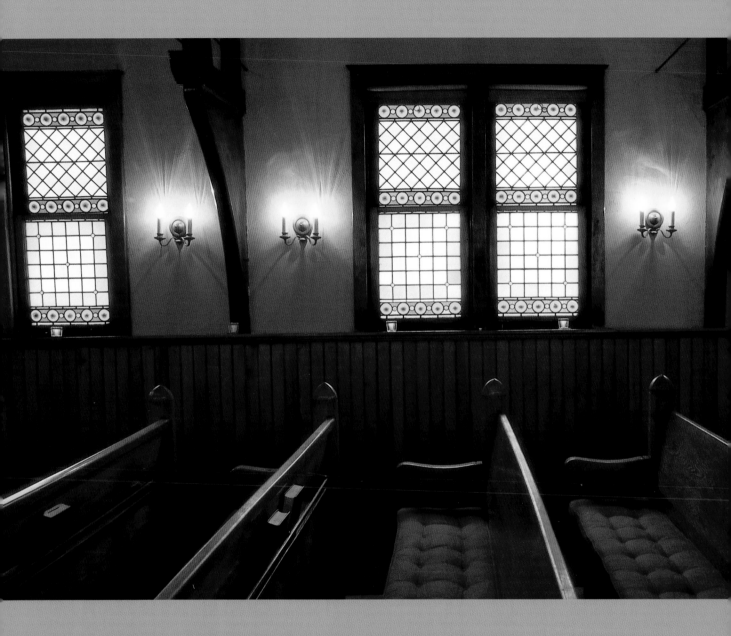

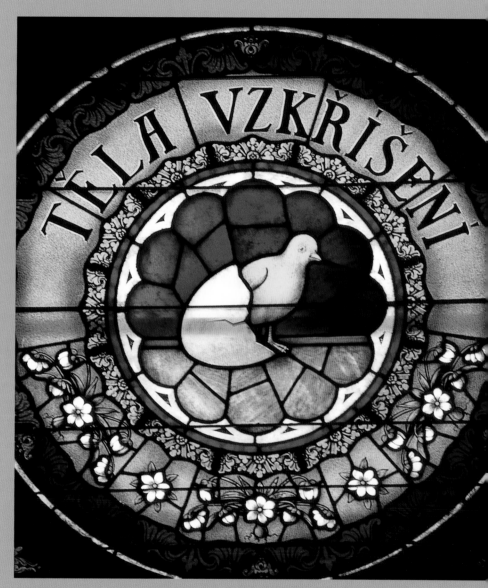

PREVIOUS PAGES:

LEFT Interior of Virginia Street (Swedenborgian) Church, St. Paul (Ramsey County), 1886, Queen Anne

RIGHT Easter window at St. Wenceslaus Catholic Church, New Prague (Scott County), 1856/1907, Romanesque

FATHER O'CONNOR, already too old for parish duty, remained our pastor for the next seven years. He was a tall, pious man, austere in appearance and habits, and oblivious to the lives being lived around him until they ended; then I picture him backing his gleaming black 1926 Oldsmobile out of its narrow brick garage and raising a cloud of gravel dust as he hightailed it through town to the bedside of some dying parishioner. On Saturday afternoons he heard confessions on the hour from two o'clock until five, and I picture him praying on his knees before Our Lady's altar between his stints in the box. I was once allowed into his spare kitchen—I may have been delivering one of his meager orders of groceries—and found him reading his breviary as he dawdled over a dinner composed of sugar cookies and boiled carrots.

Father O'Connor long ago went to whatever reward awaits those who live lives as ascetic as his, and most of the parishioners I knew back then are dead as well. But his church still stands foursquare next door to his rectory, and the grass is still groomed as neatly as it was when I was the boy with the lawn mower.

As an adult I have served in various capacities in several parishes. I have taught, but not very well, CCD classes to teenagers; I have been a lector, a trustee, a Mass server; I have dismembered turkeys for church-sponsored dinners. And I have become acquainted with all type of clergyperson—the aloof, the friendly, the brilliant, the doltish, the wise, the holy—and it strikes me as miraculous that no matter who's in charge and who's helping out, the Church continues to thrive after more than two thousand years. ❧

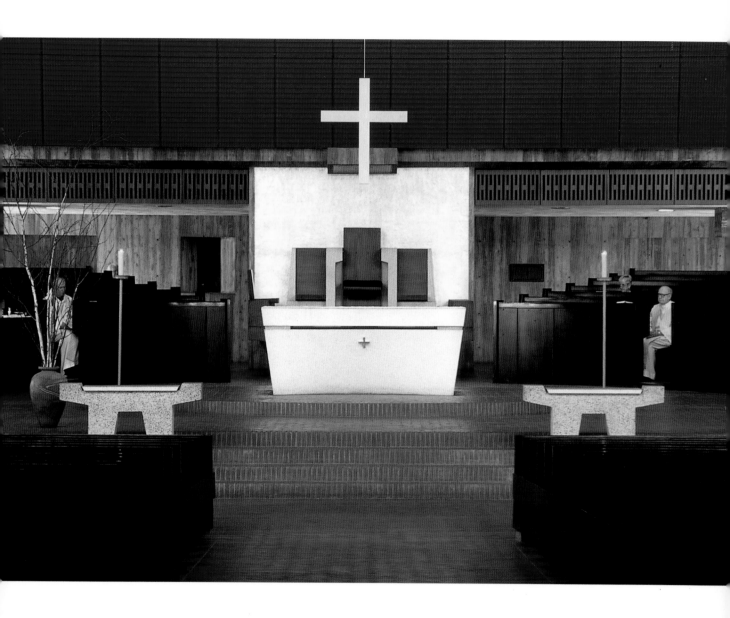

LEFT Door at St. Paul's Episcopal Church, St. Paul (Ramsey County), 1856/1912, National Register District (1993)

ABOVE Chancel and altar, St. John's Abbey Church, St. John's University, Collegeville (Stearns County), 1875/1954

BELOW Grace Lutheran Church, McGregor (Aitkin County)

RIGHT Immaculate Conception of the Blessed Virgin Mary, rural Rice County, 1886

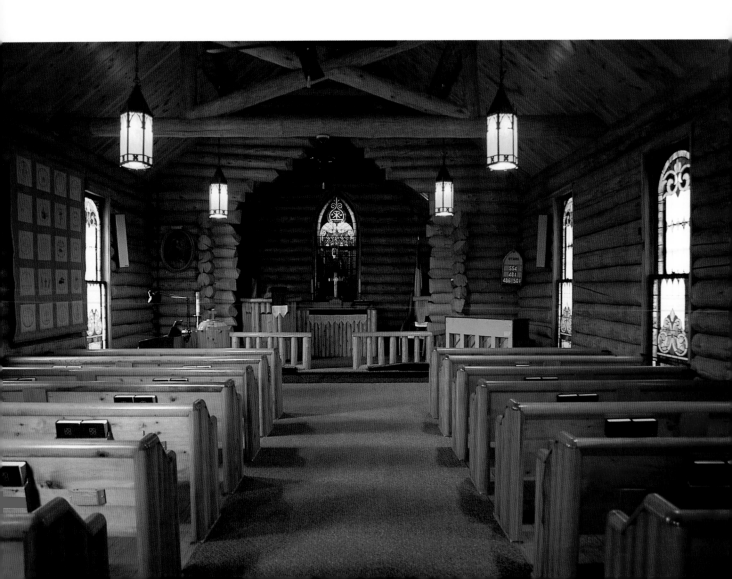

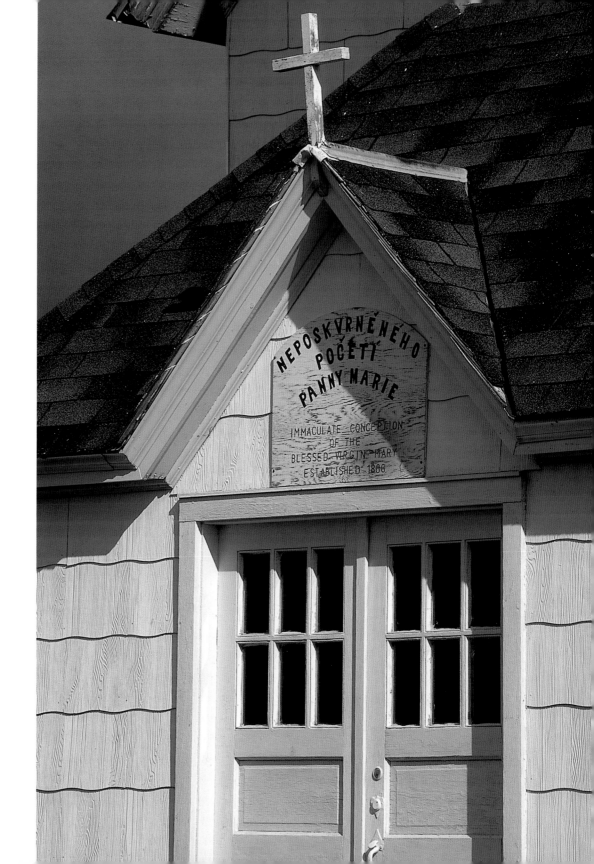

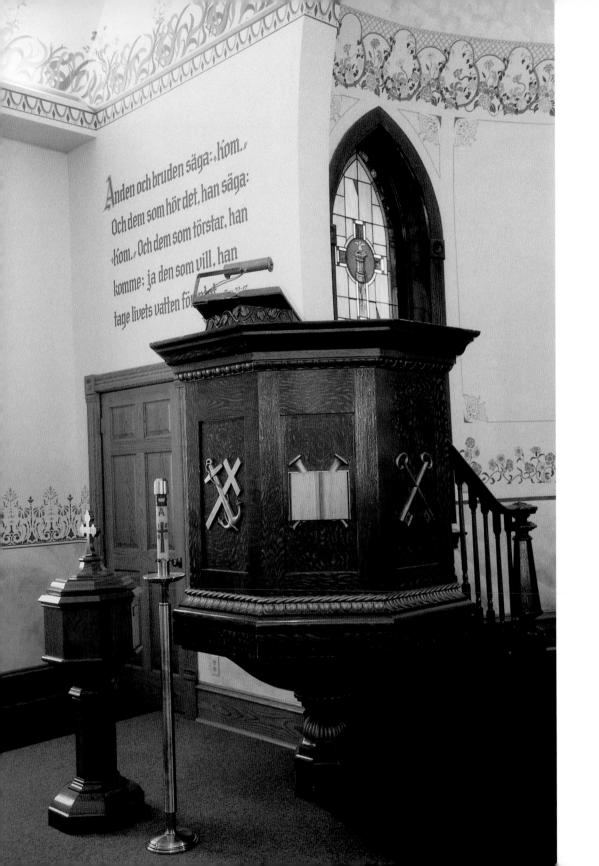

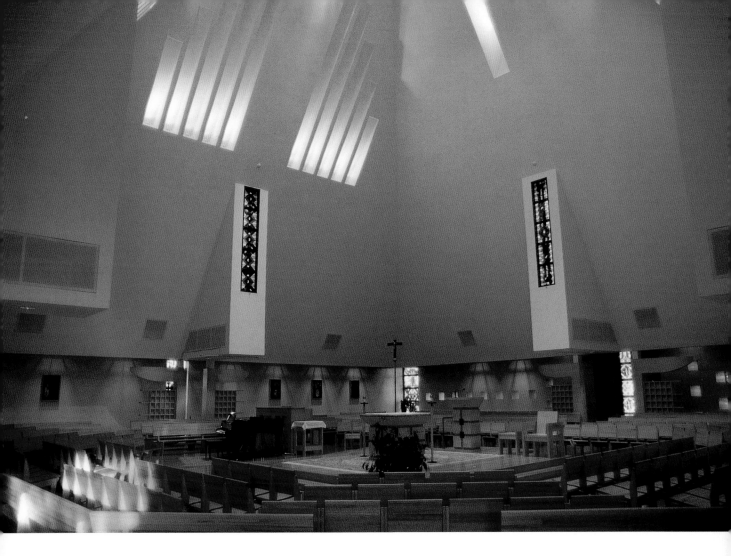

LEFT Raised pulpit at Fish Lake Lutheran Church, Harris (Chisago County), 1867/1886

ABOVE Corpus Christi Catholic Church, Roseville (Ramsey County), 1939/1992

NEXT PAGES Holy Rosary/Santo Rosario Catholic Church, Minneapolis (Hennepin County), 1878/1885, Gothic

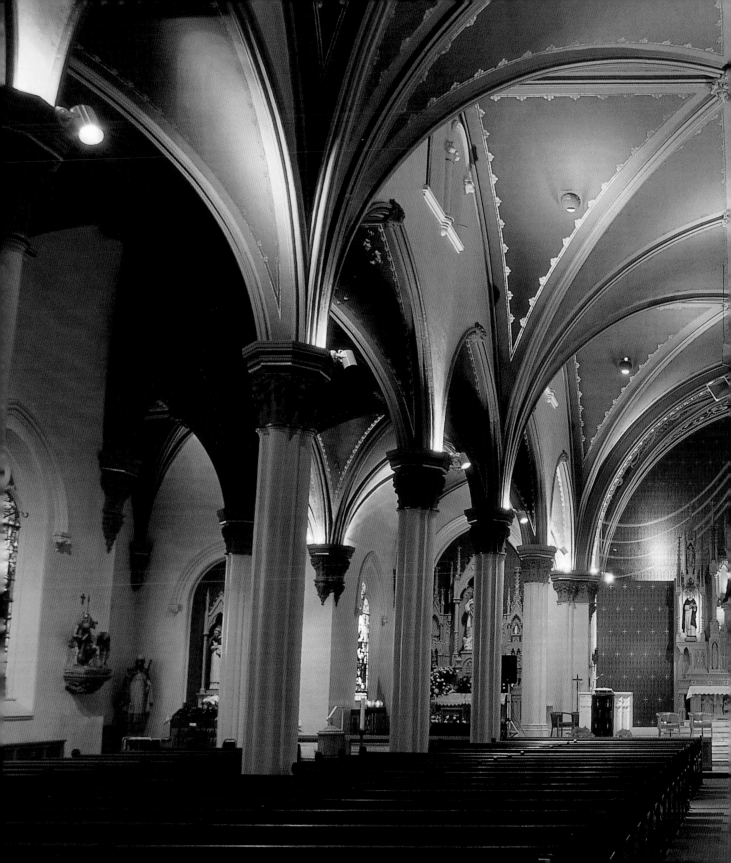

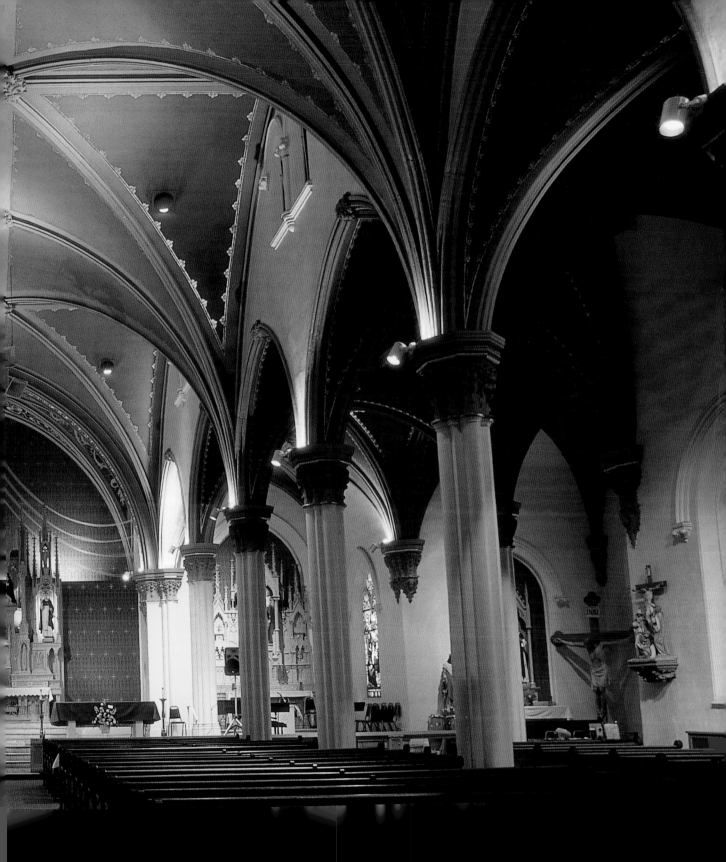

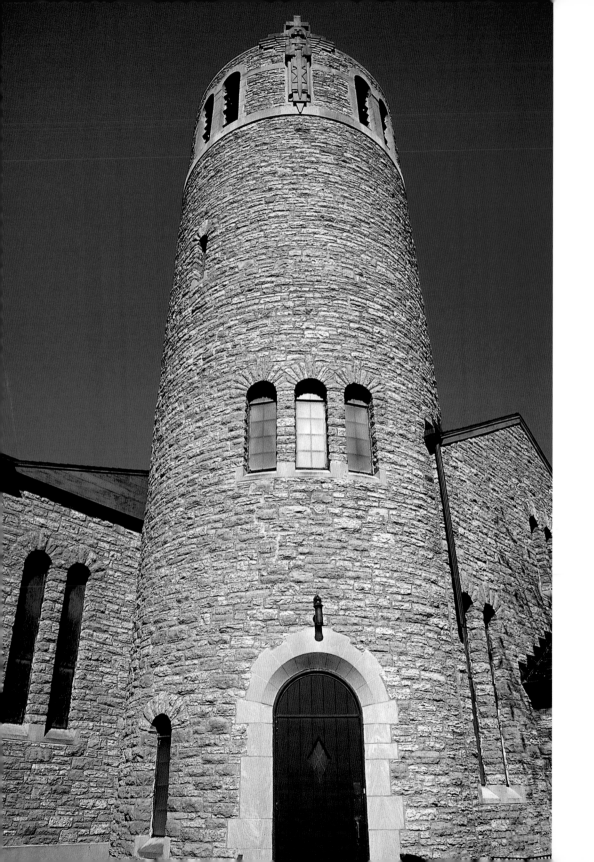

LEFT Ft. Snelling Memorial Chapel, Minneapolis (Hennepin County), 1928, National Register (1966), Richardsonian Romanesque

ABOVE Stained glass window at Ft. Snelling Memorial Chapel

BELOW Pew for the soldier who has not returned home, Ft. Snelling Memorial Chapel

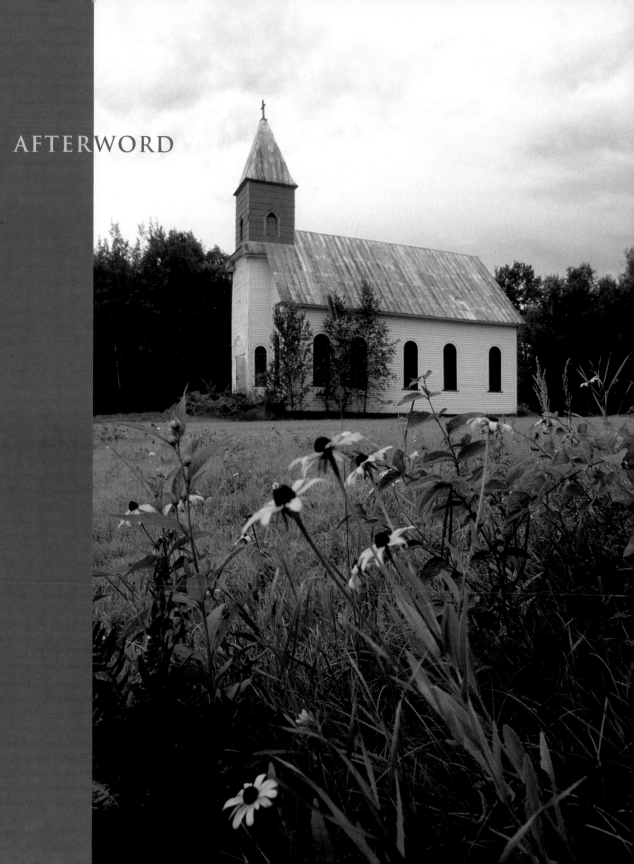

AFTERWORD

I, for one, am very glad that the age of ecumenism has finally dawned. It is hard to believe that as a schoolboy in the middle of the twentieth century, I was still living through the Counter-Reformation, when no Catholic was permitted inside a Protestant church unless to attend a wedding or a funeral of a close relative or friend, and even then you must never be a pallbearer or a member of the wedding party. In other words, you must never take part in any ceremony lest you be seen as lending your tacit approval of the Protestant way of doing things.

I recall as a fourth grader in Minneapolis—my first year in a public school—our teacher took us on a field trip to two museums in one afternoon, and between the two visits, she took us into a Protestant church to rest. I remember hunkering down in a back pew, with my eyes on my lap, looking at nothing for fear of seeming to approve of anything.

One day about six years later the entire student body of Plainview Junior and Senior High School was gathered together for an assembly at which the Gideons gave a presentation that concluded with their handing out to each student a copy of their Bible. I didn't know what an evil thing I possessed until the next day when we were ordered into another assembly where who should be standing at the microphone but Father O'Connor, fulminating against the heretical Bible that was passed out yesterday. He gave an example of how the Protestant wording differed from our own sacred scripture. Instead of the angels proclaiming, "Peace on earth to men of good will," the erroneous version said simply, "Peace to men on earth." He ordered all Catholics either to destroy their Gideon Bibles or to turn them over to him and he would see to their destruction.

The next time I entered a Protestant church many years had gone by. I was teaching high school English in Park Rapids, Minnesota, and I, along

LEFT **Kalevala Finnish Evangelical National Lutheran Church, Kettle River (Carlton County), 1915, Romanesque Revival**

with the entire faculty, attended the funeral of our stenography instructor, Violet Miller, at Riverside Methodist Church. This must have been the day my ecumenical spirit first made itself known to me, because I remember feeling pleased and excited at the thought of all of us—Lutherans, Presbyterians, Catholics, an Assembly of God worshiper, and a Jew from New York City— together in one church.

We are lucky in Minnesota to have had so many picturesque churches carefully preserved and handed down to us by previous generations. A half hour spent in any church is like taking time out from your everyday life. It's like being on a ship resting offshore, from which you can make out the hills and valleys of the mainland. You can see where you've been and where you're going. I have come to love any sort of liturgy. Witnessing a religious service, I feel myself united with everyone else in the congregation. I feel that I belong to a group of people that has striven to keep the message alive for thousands of years, the three-word message so simple that God had to send prophets and his son to earth to utter it—love one another. ❦

ABOVE Blind Lake Tabernacle, rural Cass County, circa 1940

RIGHT Gausdal Lutheran Church, Georgeville (Kandiyohi County), 1891, Gothic Revival

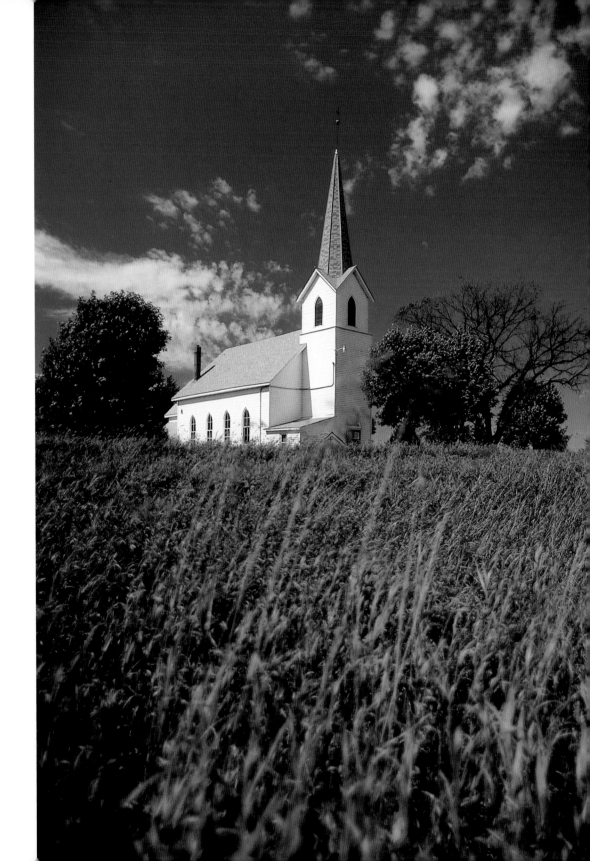

BELOW Redeemer Missionary Baptist Church, Minneapolis (Hennepin County), 1909, Prairie School, National Register (1978)

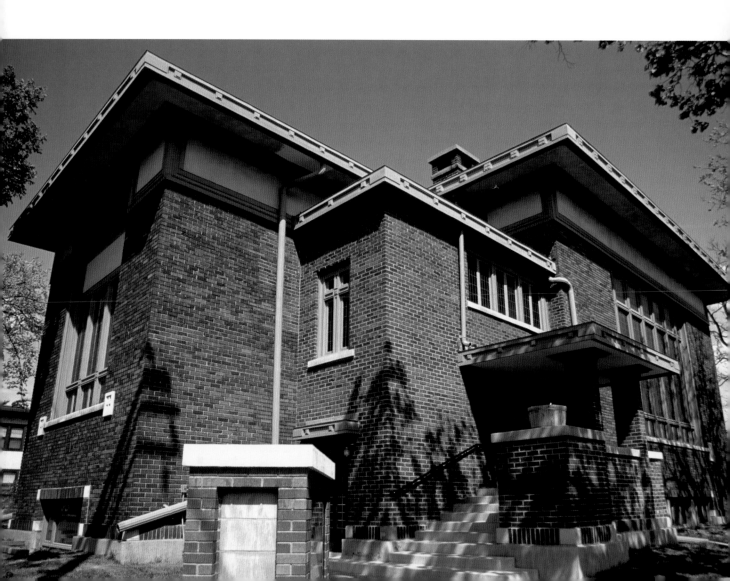

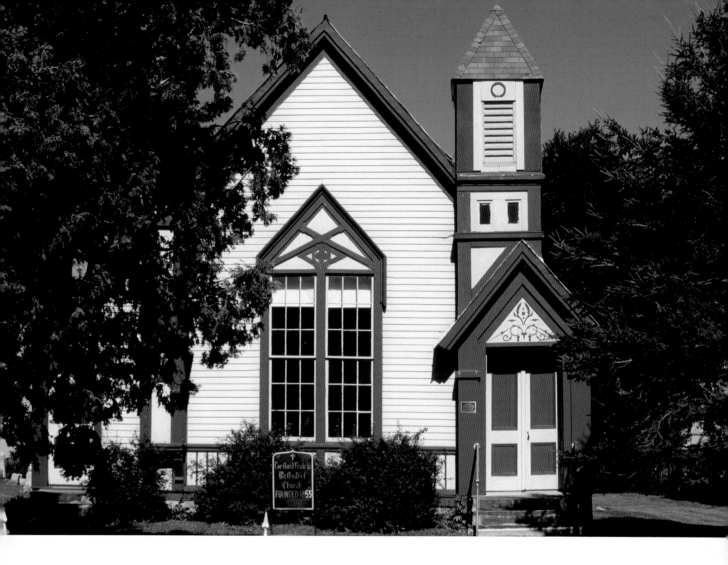

ABOVE Portland Prairie Methodist Episcopal Church, Eitzen (Houston County), 1876, Eastlake, National Register (1982)

Portland Prairie Methodist has a long history that goes back to the early 1850s, when pioneers from New England settled the area. Before the church was built, services were held in homes and the local schoolhouse. A tragedy occurred in December 1856. Ransom Scott, a young preacher, walked eight miles from his home to conduct services at Portland Prairie. Because of a blizzard, however, the worship meeting was cancelled. Against the advice of friends, Scott departed on his return journey, and he lost his way in the storm. The following spring parishioners found his remains in a ravine about two miles from the schoolhouse. They used his Bible and hymnal to establish his identity, for wolves had devoured his body, except for his feet, which were encased in boots too tough to penetrate.

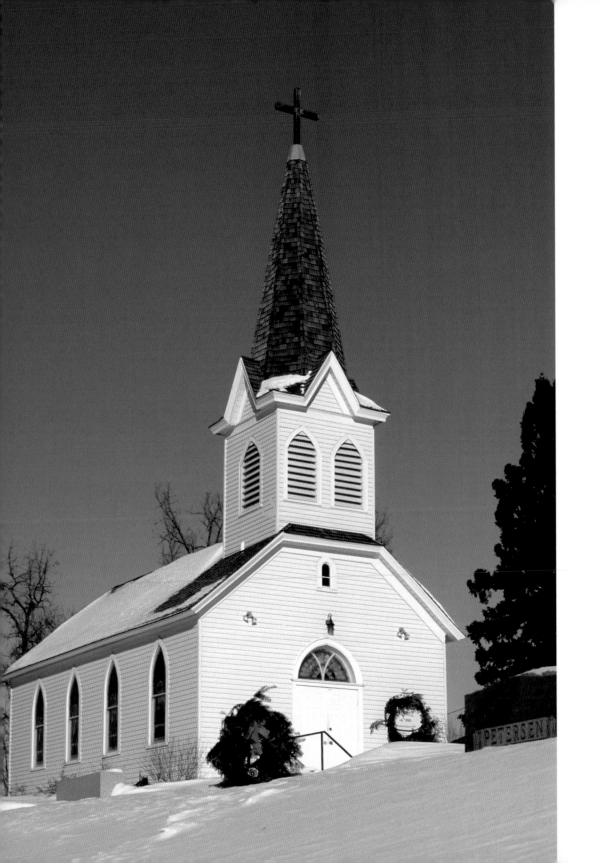

Area pioneers held services in homes and in the local school-house between 1863 and 1880, when the original church—Immanuel Evangelical—was built and organized as a congregation. Services were conducted in German and all records were kept in that language until the early 1900s. The original church building is surrounded by the old cemetery, which dates from 1871. In 1952 the congregation voted to reorganize as a Lutheran church, Mount Olivet Lutheran Church of Medicine Lake. Shortly after, a larger structure was built across the road from the original chapel. In 1990, a complete restoration project made the chapel available for weddings, funerals, and special church-related events.

BELOW Zwingli United Church of Christ, Berne (Dodge County), 1872/1894, Gothic Revival

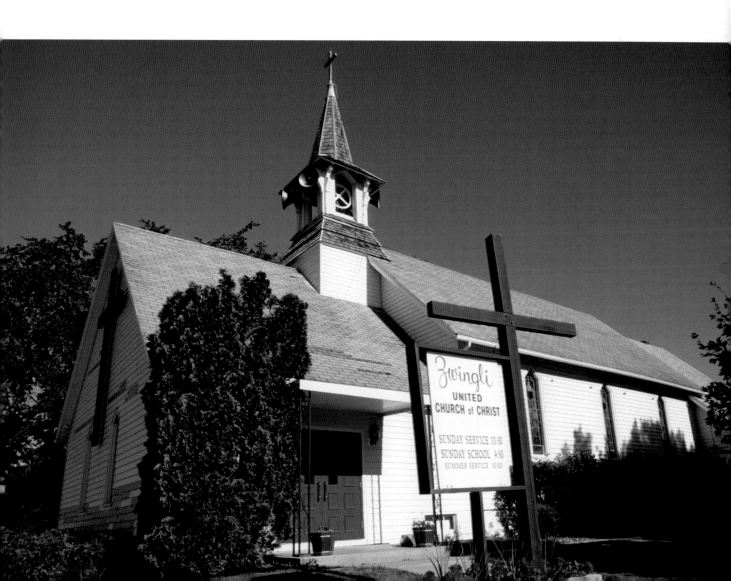

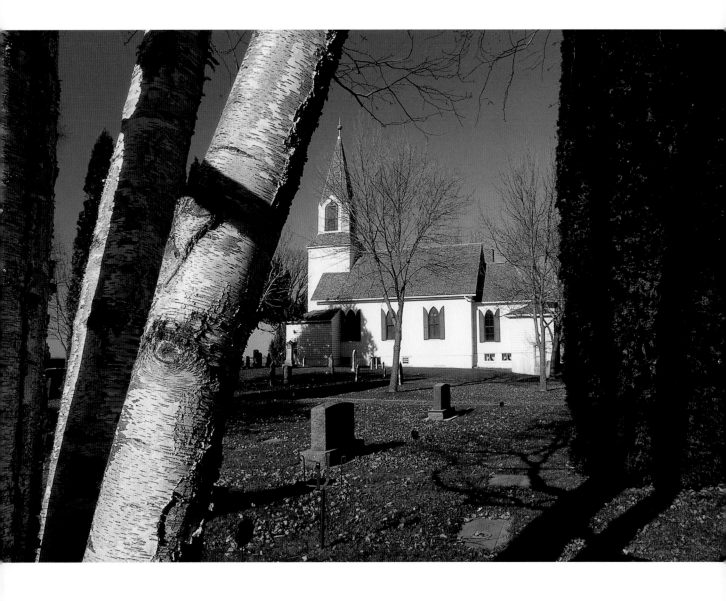

LEFT Original Ness Lutheran Church, Litchfield (Meeker County), 1861

ABOVE Ness Lutheran Church, Litchfield (Meeker County), 1874, Carpenter Gothic

NEXT PAGES St. Katherine Ukrainian Orthodox Church, Arden Hills (Ramsey County), 1950/1995, Ukrainian Baroque

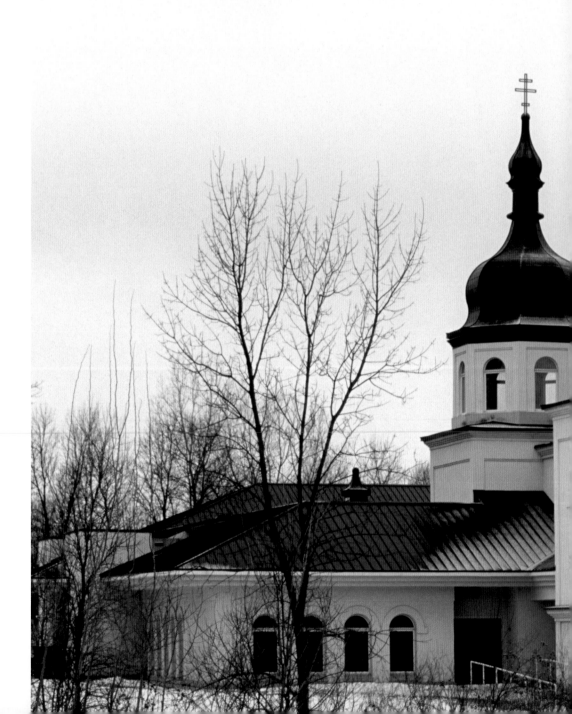

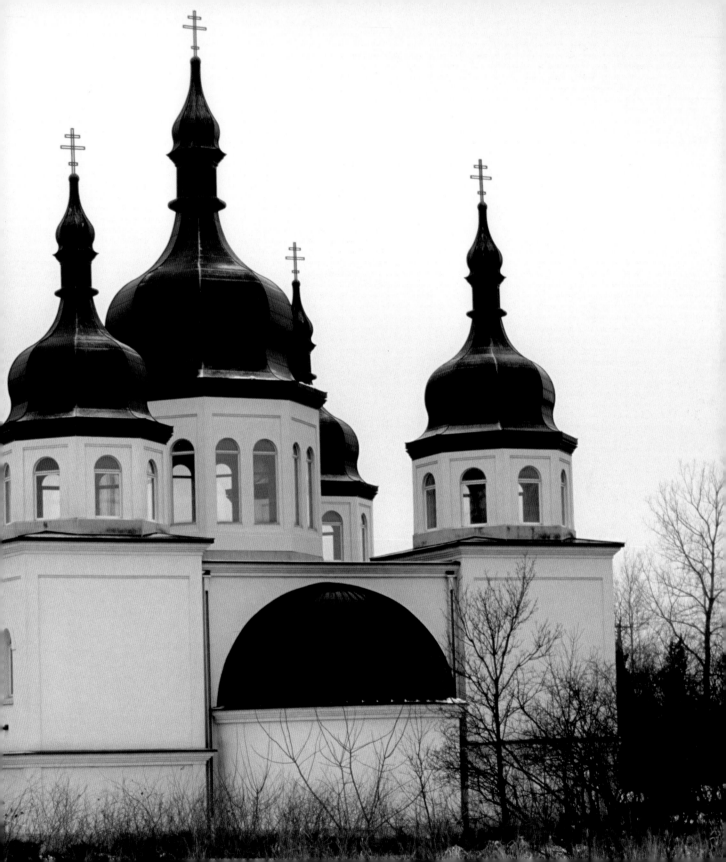

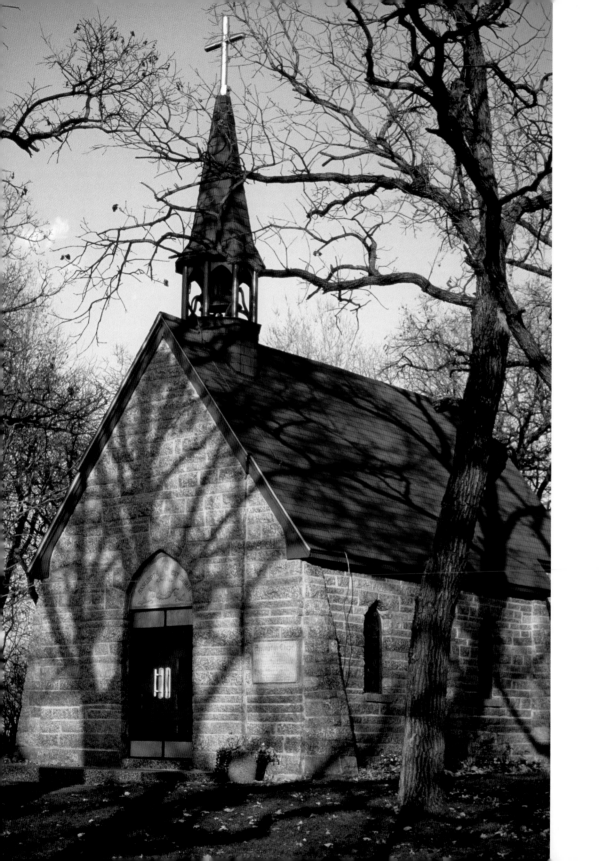

Assumption (Grasshopper) Chapel, Cold Spring (Stearns County), 1877/1951–1952, Gothic Revival

In the summer of 1876, as grasshoppers devastated crops throughout southern and central Minnesota, a local priest, Father Leo Winter, OSB, of St. James Church at Jacobs Prairie, vowed to build a chapel if God would stop the terrible plague. According to local legend, the next day the grasshoppers disappeared, and, true to his word, Father Winter began to lay plans for the chapel. A site was chosen on a hill on the outskirts of Cold Spring, and construction began on July 16, 1877. For years to come, local families made regular pilgrimages to the chapel as an act of thanksgiving. But in the summer of 1894, the chapel was destroyed by a cyclone, and for nearly sixty years the hill upon which it stood remained empty. In 1952, the centennial year of the Diocese of St. Cloud, a new chapel was completed on the same site.

Urjans Iverson cabin, rural Pope County, 1865. Served as the first Lake Johanna Lutheran Church, 1870–74

BELOW St. Michael's Catholic Church, Farmington (Dakota County), 2000

RIGHT St. Michael's Catholic Church, Farmington (Dakota County), 1895/1913, English Gothic Revival. This second church for the parish was torn down in 2002.

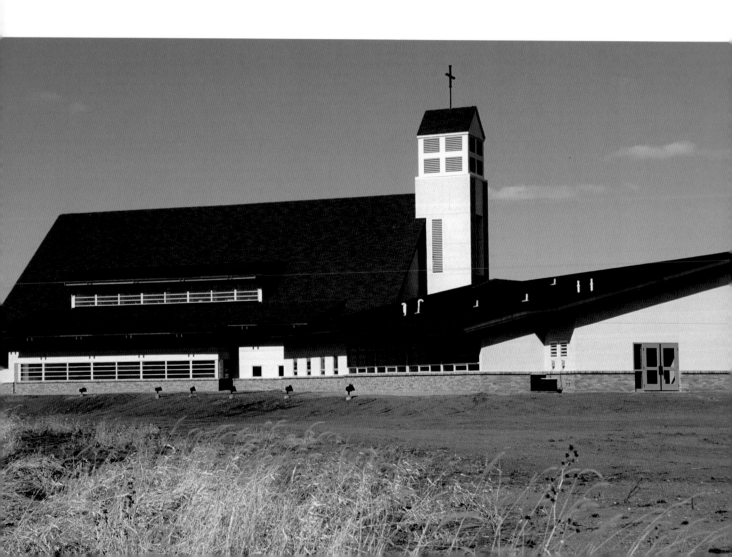

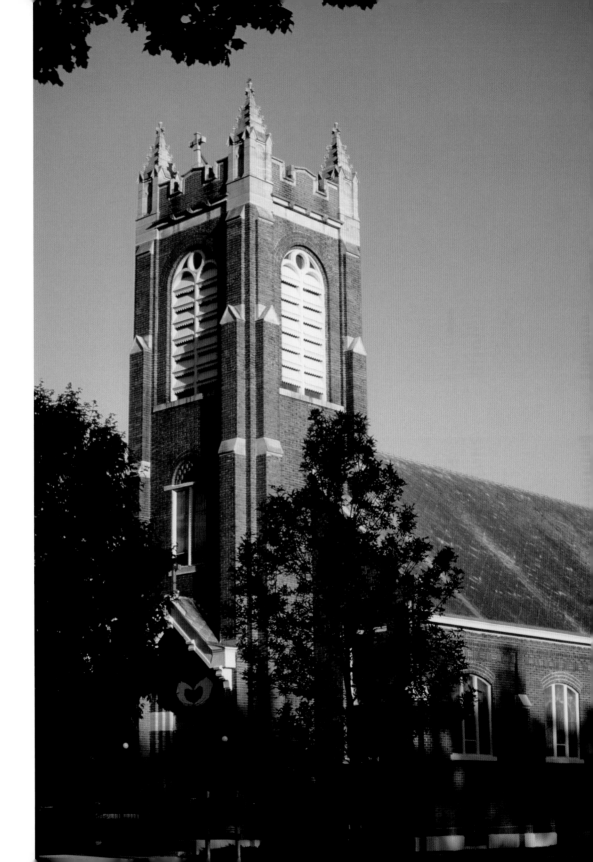

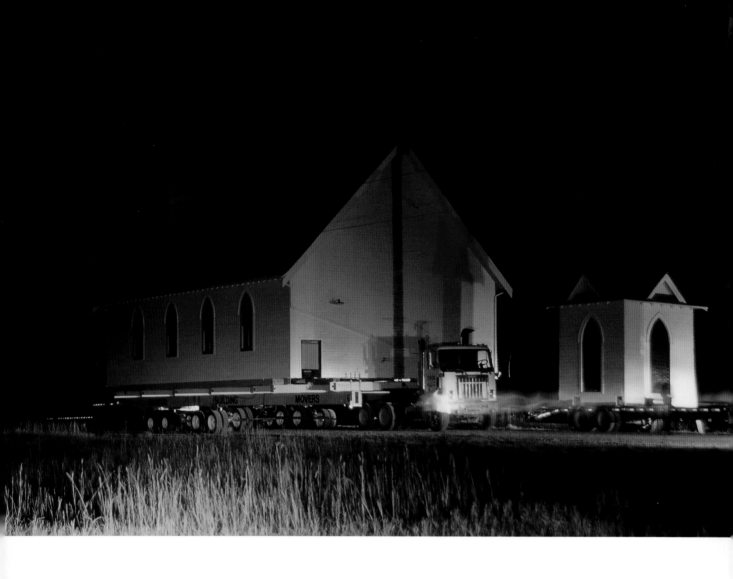

ABOVE Marble Lutheran Church, in transit from Marble Township (Lincoln County), 1879/1928, Gothic Revival

BELOW Marble Lutheran Church at its new home near New London

"We love our old church so much we are willing to give it away, if it means it stays open," said Elwood Bakke, one of Marble Lutheran's few remaining members. In spring 2004, the soon-to-be-closed church found new life. The Shores of Lake Andrew, a Lutheran camp near New London, Minnesota, was looking for a chapel, and after some negotiations the folks at Marble Lutheran agreed to sell their church to the bible camp for the sum of one dollar. The church also donated its remaining bank account, $70,000, to help with the hundred-mile move from Lincoln County to Kandiyohi County. Today the Marble Lutheran Church building is the first structure you see as you enter the Shores of Lake Andrew.

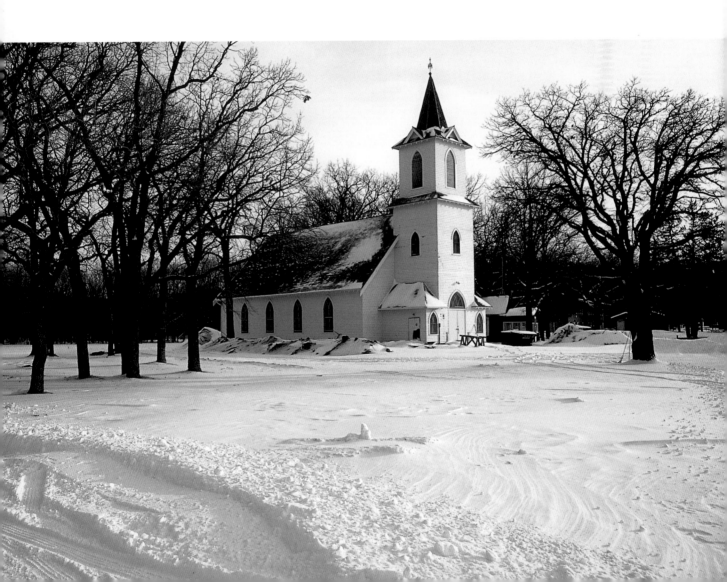